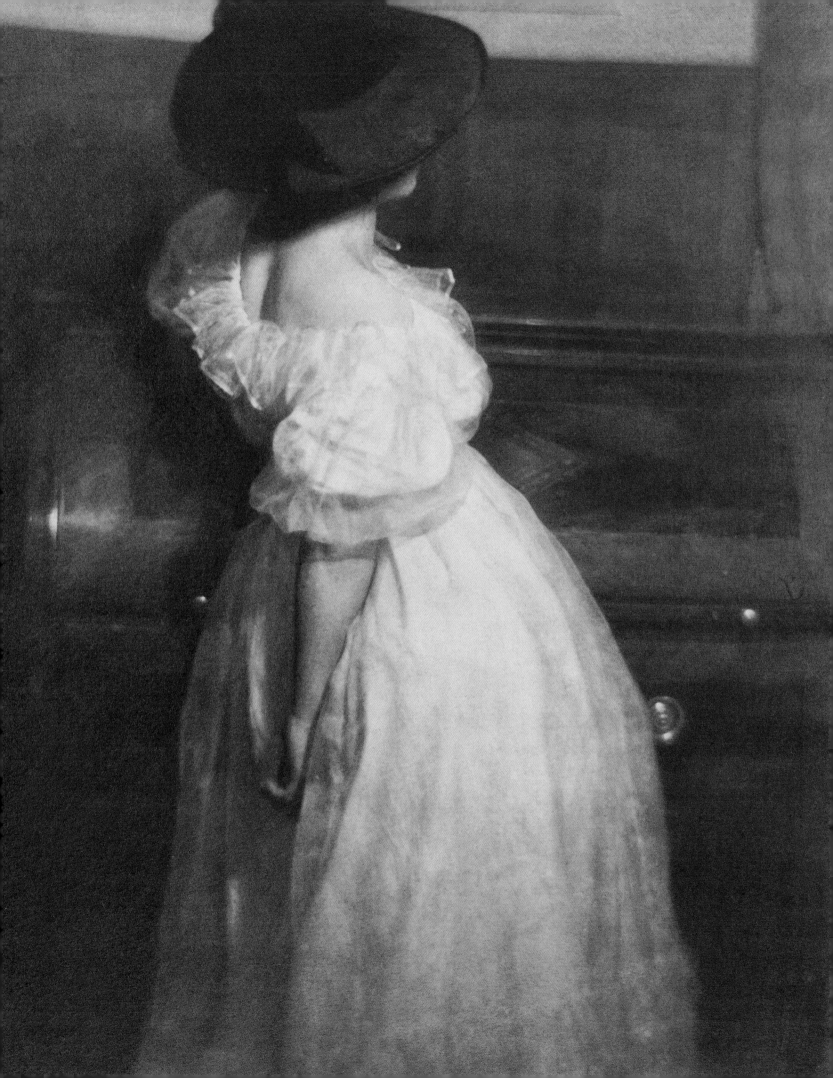

HEINRICH KUEHN AND HIS AMERICAN CIRCLE
Alfred Stieglitz and Edward Steichen

Edited by Monika Faber

With preface by Ronald S. Lauder, foreword by Renée Price,
and contributions by Monika Faber, Andreas Gruber, and Astrid Mahler

Munich · London · New York

CONTENTS

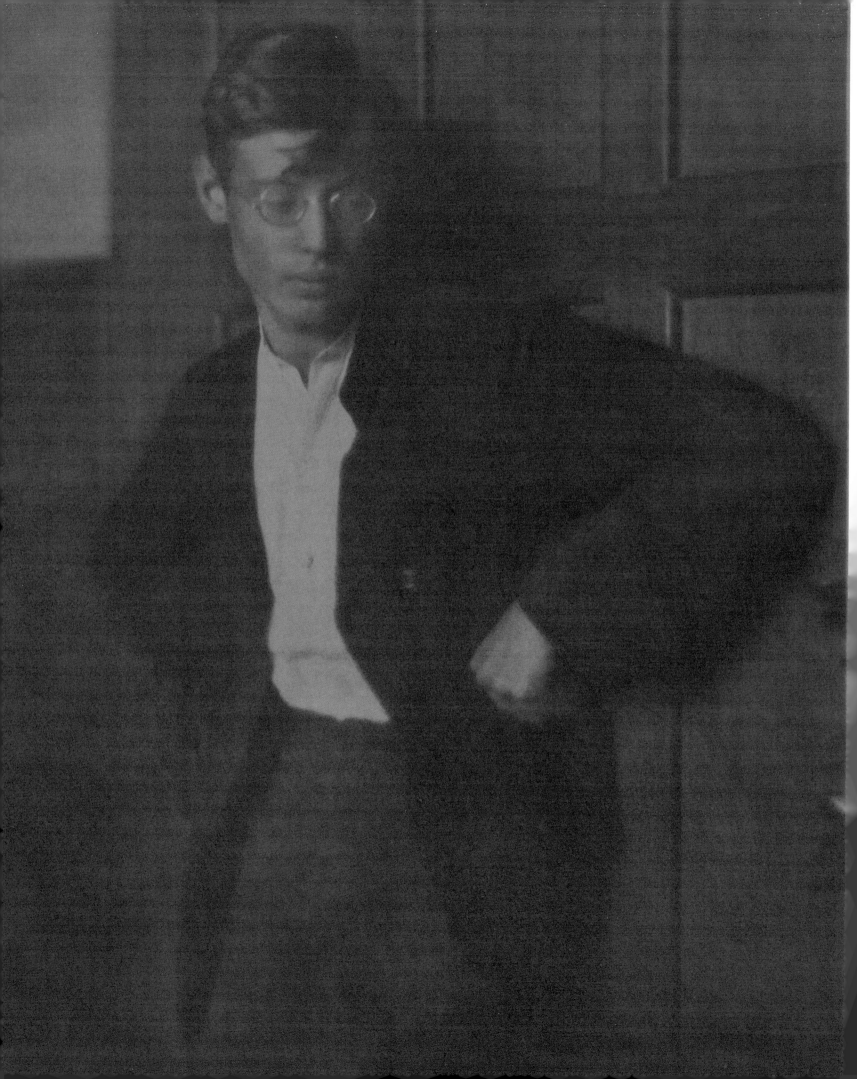

PREFACE

Photography is one of the defining art forms of the twentieth century. We often experience the world at large through photographs. But it took tremendous effort on the part of certain individuals to raise photography to the level of an art form. Heinrich Kuehn was one who saw the potential of photography and took it to the next level.

Although the Pictorialist style in which Kuehn worked lacks the harder edge of Modernist photography, its emphasis on innovative compositions and new ways of seeing prefigured many important later developments. Working alongside his peers Alfred Stieglitz and Edward Steichen, Heinrich Kuehn made tremendous advances in the art of photography.

I acquired my first Heinrich Kuehn work in 1988. I saw the piece in Vienna in a small store that sold prints and photographs. This simple image of a young boy fascinated me. Although I knew nothing about Kuehn at the time, I was compelled to learn more. I have found that there is always something mysterious in his images. Although rooted in the time and place they were made, they also have a timeless aspect that I find very compelling. My interest in the artist continued to grow, and I was fortunate to acquire more examples of his work. Because of my affinity for Kuehn, I am more than happy to see this extended examination of his work and that of his contemporaries.

This is our second photography show at the Neue Galerie, and both have been organized by the exceptional Monika Faber. We owe her a debt of gratitude for her keen insights into the work of these artists. We also thank the many lenders to this exhibition for allowing us to share these works with our viewing public. Finally, my thanks to our Director, Renée Price, for supporting the project from its inception.

This exhibition takes us back to a bygone world, and casts a very deep spell. Here we see the Austrian countryside in its unspoiled glory. We see men and women in the elegant dress of their day. We see tender scenes of children at rest and at play. Most of all, we see the exacting vision of a true artist. It is a privilege to be able to present the exquisite work of Heinrich Kuehn at the Neue Galerie.

RONALD S. LAUDER
President, Neue Galerie New York

Heinrich Kuehn, *Walther Kuehn*, 1912, gum bichromate print, 29.8 x 25.1 cm (11 ¾ x 9 ⁷⁄₁₆ in.). Private Collection

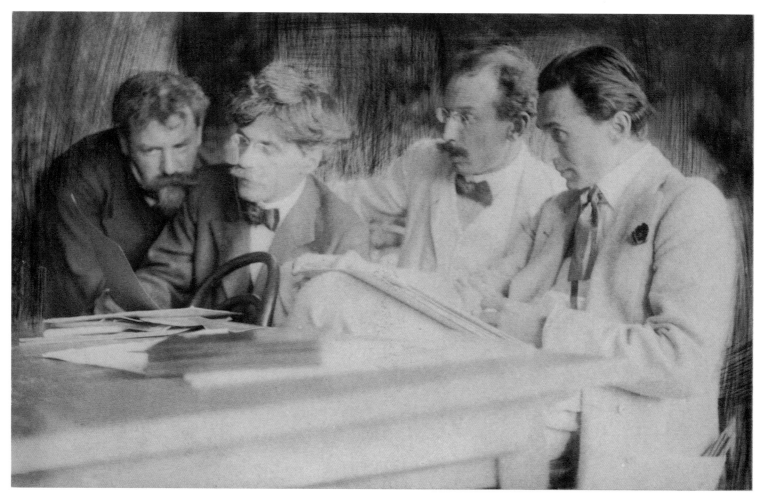

Frank Eugene, *Steichen, Kuehn, Stieglitz, and Frank Eugene in Tutzing Admiring the Work of Frank Eugene*, 1907, platinum print, 10.2 x 16.2 cm (4 x 6 ⅜ in.). The Metropolitan Museum of Art, Rogers Fund, 1972 (1972.633.132)

FOREWORD

Our museum, Neue Galerie New York, has always had a dual allegiance, as suggested by its name: It embraces both the city in which it is located and the Germanic culture upon which its exhibitions and collections are based. In all our programs, there is a constant interplay between our European roots and our American home.

The Heinrich Kuehn exhibition is founded on just such a duality. Kuehn (1866–1944) spent the majority of his career working in Austria. Yet he developed artistically alongside two major American photographers: Alfred Stieglitz (1864–1946) and Edward Steichen (1879–1973). Though both of them worked primarily in the United States, each had roots in Europe. Stieglitz was born and grew up in the United States, but spent nine formative years, from the ages of 17 to 26, attending high school and college in his father's native Germany. Steichen was born in Luxembourg and did not become an American citizen until the age of 21.

The three shared a passionate commitment to the burgeoning field of photography, and became close friends. Stieglitz dedicated exhibitions at his influential New York gallery, known as 291, to both Kuehn and Steichen, and reproduced their work frequently in his seminal photography magazine, *Camera Work*. Under the influence of Stieglitz and Steichen, Kuehn shifted from making large landscapes to creating intimate, open-air studies of members of his family. Although his work is rooted in the late-nineteenth-century Pictorialist style, its increasing use of unusual angles and psychological intimacy—again, showing the influence of both Stieglitz and Steichen—anticipates groundbreaking modernist photography of the 1920s. We are pleased to share the work of all these artists with our audience.

This is the first New York museum show to focus on Heinrich Kuehn, an often overlooked, but central figure in early twentieth-century photography. Born into a wealthy family in Dresden, he was able to follow his passion and became a member of Vienna's Camera Club. He strove to elevate photography to an art form, and felt an allegiance with members of the Vienna Secession and their common quest for the *Gesamtkunstwerk*, or total work of art. Gustav Klimt and Heinrich Kuehn shared certain commonalities. On a technical level, each used a viewfinder to develop their landscape motifs. On a broader level, each looked both to the past and to the future in their work, straddling the nineteenth and the twentieth centuries stylistically. Kuehn's scientific background enabled him to experiment freely with photographic techniques, particularly the gum bichromate process, which allowed for a liberating choice of pigment and paper. His atmospheric work (described as *Stimmungskunst*—art of mood) is marked by a superb sense of composition and rich tonal range.

Our curator for this exhibition is Monika Faber, a noted expert in this field and former Chief Curator of the Albertina photography collection, who is now in charge of the Photoinstitut Bonartes in Vienna. Dr. Faber also served as the Curator for the initial foray by the Neue Galerie into the

field of photography, the 2005 exhibition "Portraits of an Age: Photography in Germany and Austria 1900–1938." We are again indebted to Dr. Faber for her vast knowledge and network of resources, both of which were employed in assembling this marvelous exhibition.

We are most grateful to the Heinrich Kuehn family for their invaluable support of our exhibition and are pleased to acknowledge all the lenders to the exhibition, who so generously allowed their photographs to be a part of this endeavor. Judy Hudson provided the sensitive design for the exhibition catalogue, and Tom Zoufaly offered his usual invaluable support on the installation design for the show. Hans P. Kraus, Jr. and his staff graciously made available materials for the installation. The staff of the Neue Galerie—especially Scott Gutterman, Deputy Director, Janis Staggs, Associate Curator, Sefa Saglam, Registrar and Director of Exhibitions, Christina Graham, Assistant to the Registrar, Liesbet van Leemput, Graphic Designer, and Michael Voss, Preparator—all contributed to this exhibition, and I wish to express my most sincere thanks to them for all their valiant efforts.

RENÉE PRICE
Director, Neue Galerie New York

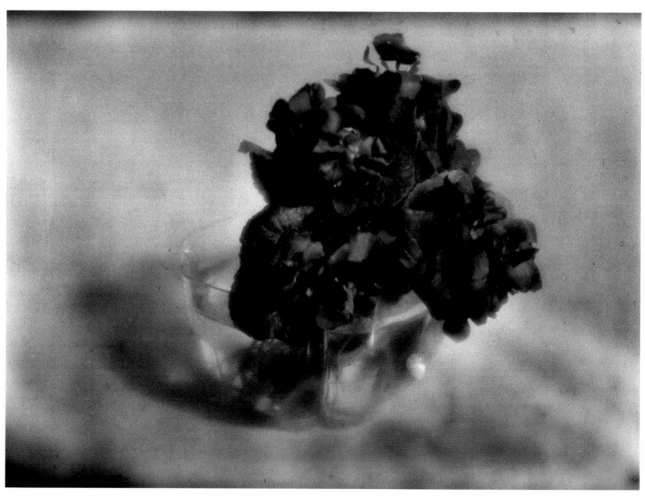

Heinrich Kuehn, *Still-Life with Violets*, ca. 1908, autochrome, 13 x 18 cm (5 ⅛ x 7 ⅛ in.). Österreichische Nationalbibliothek, Bildarchiv, Vienna

ACKNOWLEDGMENTS

Art Installation Design, New York
Leah Ammon, Campbell
Paul and Stefan Asenbaum, Vienna
Peter Bacanovic, New York
Jennifer Belt, New York
Christian Brandstätter, Vienna
Maria Bueno, New York
Jackie Burns, Los Angeles
Thomas P. Campbell, New York
Billy Corgan, Chicago
Malcolm Daniel, New York
Johannes Faber, Vienna
Randi and Bob Fischer, San Francisco
Peter Galassi, New York
Barbara Galasso, Rochester
Hermann Geissler, Vienna
Christina Graham, New York
Howard Greenberg, New York
Richard and Ronnie Grosbard, New York
Margarete Heck, Vienna
Max Hollein, Frankfurt am Main
Judith Hudson, New York
Peter Huestis, Washington, D.C.
Raymond E. Kassar, Wellington
Ingrid Kastel, Vienna
Martin Keckeis, Vienna
Annette and Rudolf Kicken, Berlin
Kaelen Kleber, New York
Hulya Kolabas, New York
Manfred Kostal, Vienna
Hans P. Kraus, Jr., New York
Elizabeth Szancer Kujawski, New York
Christl Lammer, Innsbruck
Rachel Laufer, Jerusalem
Mack Lee, Winchester
Laura Leffler, New York
Harriet and Noel Levine, New York
Jill Lloyd, London
Agapita Judy Lopez, Abiquiu
Russell Lord, New York
Glenn Lowry, New York
Aimee L. Marshall, Chicago
Peter MacGill, New York
Sarah Meister, New York
Cassity Miller, New York
Angelika Milos, Vienna
Alison Nordstrom, Rochester
Vlasta Odell, New York
Ben Ogilvy, Winchester

Wataru Okada, Rochester
Olaf Peters, Hanover
Hans Petschar, Vienna
Ernst Ploil, Vienna
Karen Polack, New York
Peter Prokop, Vienna
Howard Read, New York
Jerry Rivera, New York
Ellen Robinson, New York
Marshall Rose, New York
Christian Schindler, Vienna
Ina Schmidt-Runke, Berlin
Jennifer Russell, New York
Klaus Albrecht Schröder, Vienna
Peter Selz, Berkeley
Bruce Silverstein, New York
Michael Slade, New York
James S. Snyder, Jerusalem
Siegfried Schöffauer, Vienna
Diether Schönitzer, Innsbruck
Dietmar Siegert, Munich
Alexander Spuller, Vienna
Christian Tucek, Vienna
Magdalena Vukovic, Vienna
Christian Wachter, Vienna
Thomas Walther, Zurich
Laurie Platt Winfrey, New York
Theo Wirth, Vienna
Christian Witt-Dörring, Vienna
Daniel Wolf, New York
Sarah and Gary Wolkowitz, New York
Julie Zeftel, New York
Tom Zoufaly, New York

*Our thanks also go to those lenders
who prefer to remain anonymous.*

Heinrich Kuehn, *Sirócco*, 1899–1901, gum
bichromate print, 55.2 x 73.7 cm (21 ¾ x 29 in.).
The Metropolitan Museum of Art, Alfred Stieglitz
Collection, 1933 (33.43.279). © Estate of
Heinrich Kuehn/Courtesy Galerie Kicken Berlin

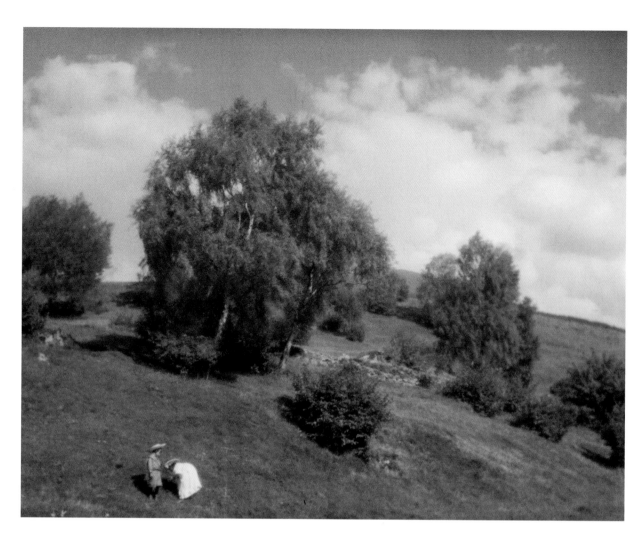

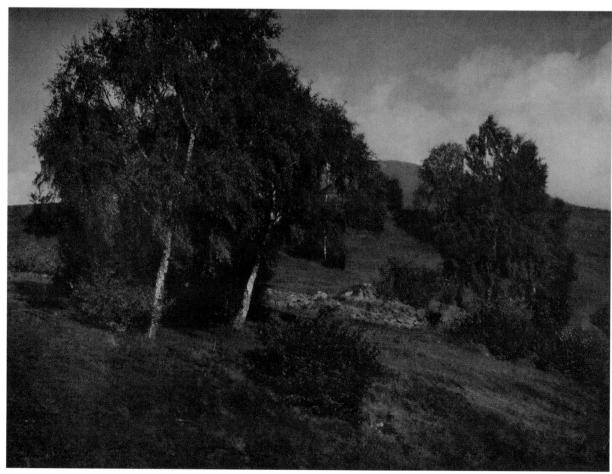

PARALLELS AND DIVERGENCES

Heinrich Kuehn, International Art Photography, and Alfred Stieglitz

MONIKA FABER

In Continental Europe, [...] enormous strides in the right direction have been made within the last few years. Vienna, with its influential club, full of enthusiastic workers like Henneberg, Bergheim, Watzek, Kuehn, Strakosch, and many others, has led the way in founding a new school of pictorial photography, tearing itself away from the accepted conventionalities and bringing out individualism whenever possible.

Alfred Stieglitz, 1899[1]

Ever since I saw the outstanding American photographs, my own prints no longer satisfy me.

Heinrich Kuehn, 1905[2]

Postcard of the Igler Hof Spa-Hotel, ca. 1910

Opposite:
Heinrich Kuehn, *Landscape*, 1904, after original negative

Alfred Stieglitz, *Landscape, The Tyrol*, 1904, platinum print, 23.5 x 31.4 cm (9 ¼ x 12 ⅜ in.). The J. Paul Getty Museum, Los Angeles. © 2012 Georgia O'Keeffe Museum/ Artists Rights Society (ARS), New York

These two men were *the* most recognized, outstanding protagonists of the international Pictorialist movement, in which amateurs sought, from around 1890 onward, to lend artistic ambition to a technological medium. Their photographs, hung side by side in large exhibitions from Vienna to London, from Hamburg to Paris, illustrated the lavishly designed magazines of the amateur photography clubs, and provoked discussions in artistic circles. They and their friends countered the mass reproduction of photography that had just begun with a radical individualism. They were interested in different themes, and their works could scarcely have been more different. But they were similar in their demand for the conscious design and perfect execution of every single photograph. Few of their like-minded contemporaries were as uncompromising as they: on August 20, 1904, they met personally for the first time: Heinrich Kuehn (1866–1944), born in Dresden but living in Austria, and the American Alfred Stieglitz (1864–1946).

The renowned spa-hotel Igler Hof, near Innsbruck in the Tyrol, with its grand mountain panorama, provided the ideal backdrop for the two tall, elegant gentlemen around forty, with their moustaches, monocles, and the self-confident attitudes of wealthy bourgeois accustomed to success. Both were staying in the Alps for reasons of health: Kuehn had moved there full-time, since he suffered from asthma, and Stieglitz was merely seeking brief recuperation after fainting on his European journey, but his choice of a site near Kuehn's residence was probably no coincidence. For ten years they had admired each other's work, and for the next five years they

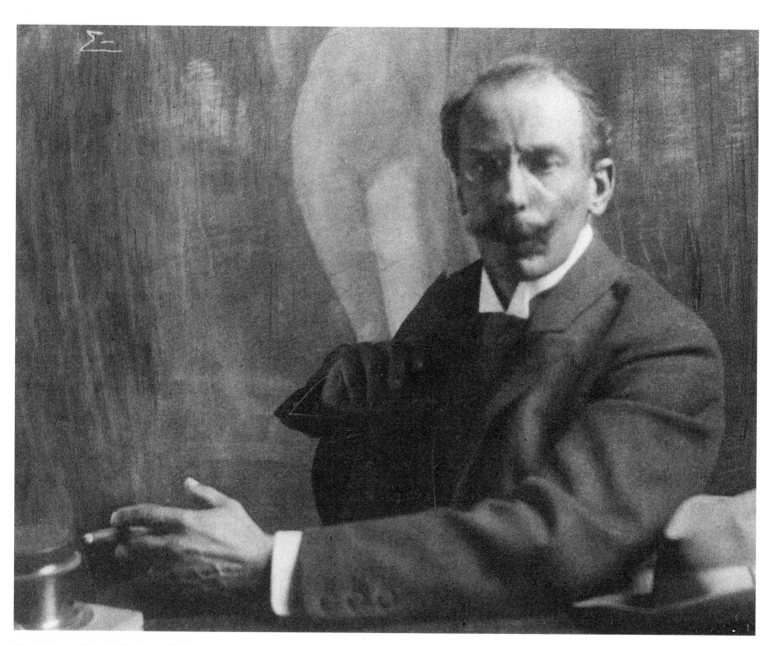

Frank Eugene, *Heinrich Kuehn*, ca. 1907, platinum print, 11.8 x 14.8 cm (4 ⅝ x 5 ⅞ in.). Private Collection

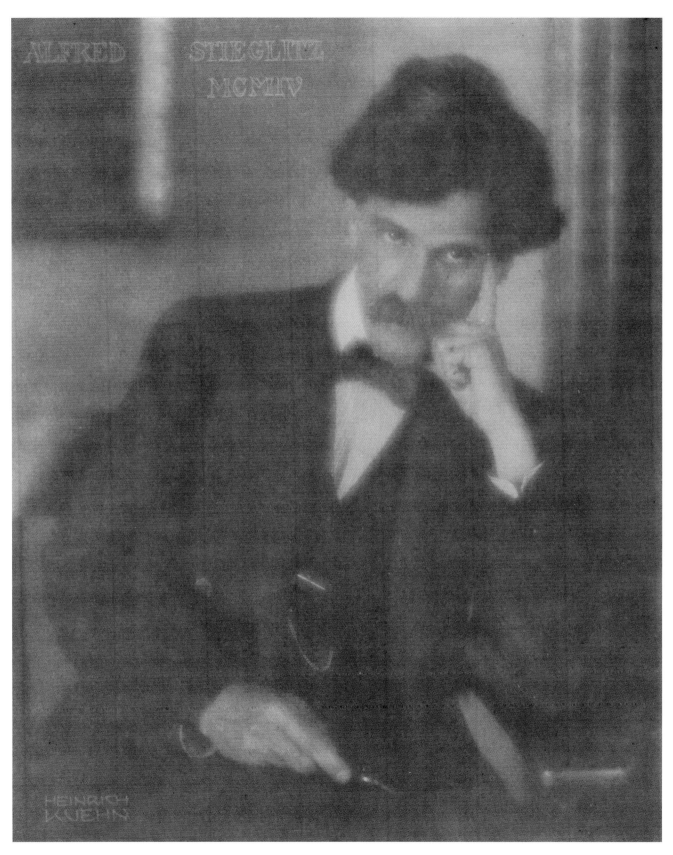

Heinrich Kuehn, *Alfred Stieglitz*, 1904, gelatin silver print, toned, 25.2 x 20.1 cm (9 ⅞ x 7 ⅞ in.). Courtesy of George Eastman House, International Museum of Photography and Film

would remain in close contact, and for more than two decades after that would exchange letters, photographs, and journals regularly.

Over the next few days they took photographs together in the surrounding areas, each taking pictures so similar to the other's that they testify to an extraordinary understanding of each other's work. This is astonishing given that the basic character of their photographs had always been fundamentally different, and in the coming years and decades they would evolve in completely antithetical directions.

The extraordinary respect these two men had for each other has its roots in their biographies, in their social milieu, in the unreserved conviction with which they regarded the possibilities of a full-fledged art movement in this technological medium, and last but not least in the missionary zeal that drove them. From the parallels in their development—but above all from a growing, mutual lack of understanding after 1911—it is possible to draw an eloquent picture of international interactions in the "amateur photography movement," on the one hand, and dramatically transforming regional relationships, on the other. Each saw himself as anything but a "political" artist, but politics eventually caught up with them. The effortless harmony between the polyglot descendant of German ancestors who lived in the United States and the German from Dresden living a secluded life in the Alpine world of the Tyrol was the result of the intellectual world of the educated classes in the second half of the nineteenth century, which culminated artistically in the Secession movements of the fin de siècle. The First World War shattered that seemingly ideal world, as well as the new terrain conquered by photography, the medium they had so vehemently claimed all their lives. Yet the reactions of the two photographers to the new circumstances were diametrically opposed: during the second half of his life, Heinrich Kuehn clung to the ideas of modernism around 1900 and sought to refine them; Alfred Stieglitz, by contrast, championed the new avant-garde, and his own work evolved.

The following essay primarily seeks to analyze the particular qualities and developments of Heinrich Kuehn's work, but these parallels with and divergences from Alfred Stieglitz and his circle are also examined.

AMATEURS

Anyone who wished to achieve anything serious in photography had to be an "amateur." That argument united Kuehn and Stieglitz right up to the end,[3] and with it they hoped to lead the photograph out of the "dregs" of commercial applications and the associated compromises to a "free" medium of artistic ambitions. The idea originated in England, where the journal The Amateur Photographer under Alfred Horsley Hinton had been promoting new paths in photography since 1884. The Society of Amateur Photographers of New York was founded that same year. In 1887 the Club der Amateur-Photographen in Wien (later renamed the Wiener Camera Club), was founded, having set itself the goal of "creating an understanding for 'pictorial photography' in broad circles."[4] In 1888 it was joined by the Photo-Club de Paris, and in 1892 amateurs in London formed the Linked Ring—to mention only a few of the examples of the international wave of associations founded.

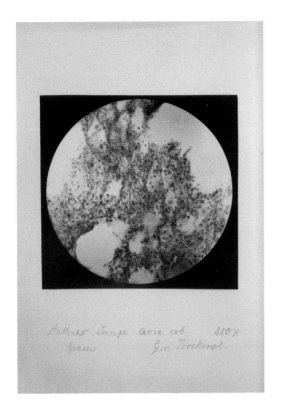

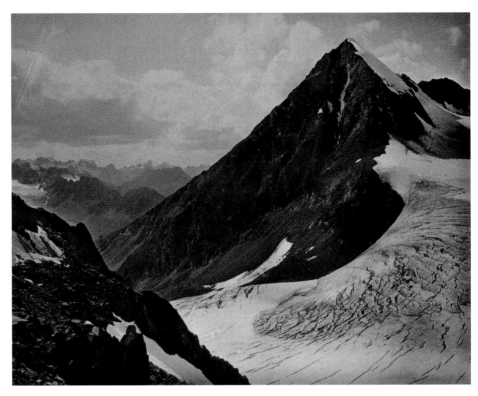

The *Internationale Ausstellung künstlerischer Photographien* organized in Vienna in 1891 has been regarded as a decisive event on the path of photography from private occupation of amateurs to "serious" art. In contrast to the practice of all previous photo exhibitions, it was not about winning prizes or medals but about a rigorous jury of artists.[5] Numerous of the presentations described as "salons" would follow without causing the significance of this show to be forgotten: "The rapid spread of interest in pictorial photography which took place among Vienna workers after their first invitation exhibition there will be well remembered," wrote the English photographer and critic George Davison as early as 1899.[6]

Amateur photographers were a symptom of the bourgeoisie, which grew increasingly prosperous in the Western world during the second half of the nineteenth century, providing a larger group of people with time for personal interests. In contrast to the generation of their fathers, some of whom accumulated great wealth and displayed it in quite traditional ways, many of the sons had different values.

Although the bourgeois who rose in society shared the nobility's prejudices against earning money, for many, aristocratic idleness was not the model to be imitated but rather "a certain intellectual attitude, a certain lifestyle, turning toward and having roots in the spheres of culture, the world of the mind, and art," which in Germany came to be called the *Bildungsbürgertum*, or "educated bourgeoisie."[7] The canon of values of the *Bildungsbürgertum* had a powerful influence, including on the Stieglitz family in the United States. Collecting paintings, regular visits

Heinrich Kuehn, *Photomicrograph of a tissue sample (lung tissue wth anthrax bacillus, enlarged 250 times)*, 1888–90, albumen paper, 24 x 16 cm (9 ½ x 6 ¼ in.). Private Collection

Heinrich Kuehn, *Mountain Range/Gebirge*, ca. 1890, collodion-chloride print, 19.7 x 24.9 cm (7 ¾ x 9 ¾ in.). Private Collection

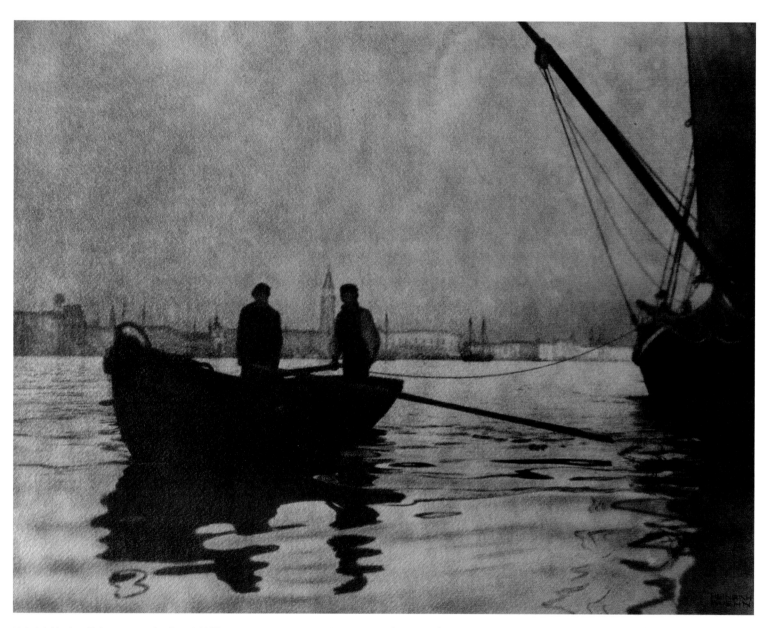

Heinrich Kuehn, *Fishermen on the Canal*, 1908, gum bichromate print, 50.8 x 71.1 cm (20 x 28 in.). Collection Raymond E. Kassar, Courtesy Cheim & Read, New York. This image was reproduced in *Camera Work* in 1911.

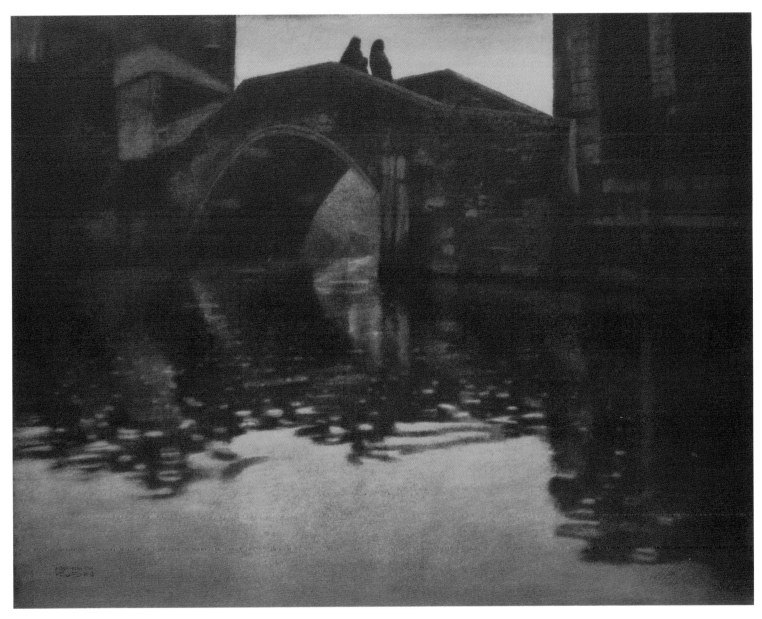

Heinrich Kuehn, *Venetian Bridge/Venezianische Brücke*, 1902–03, gum bichromate print, 51.5 x 65.9 cm (20¼ x 25¹⁵⁄₁₆ in.). The Metropolitan Museum of Art, Alfred Stieglitz Collection, 1933 (33.43.280). © Estate of Heinrich Kuehn/Courtesy Galerie Kicken Berlin

to the theater, and studying classical literature, even personal engagement in the support of cultural institutions were all widespread activities. Yet in no other area did people attempt to be active creatively themselves. That occurred only in photography, which wealthy bourgeois had learned to master in the wake of the technical simplification of the medium in the 1880s. What began as a highly modern pastime, however, pursued in clubs almost as a sport, developed into an international campaign that called for an aesthetic revolution—and ultimately carried it out, in a certain sense. Contemporary painters who had set out on new paths were admired and supported, but professional photographers were not considered up to the innovation demanded of their photographic achievements—probably rightly so, for a variety of reasons.

Here it was the amateurs, who were not directly involved with the material professionally and thus had no financial interest, who seemed to be in a position to find new solutions, as suggested by Alfred Lichtwark in 1893–94, the first museum director to open up his institution to this new medium.[8] The amateurs also had the time necessary to work with and perfect the new, complicated printing techniques being advocated. They alone believed that the production of images from a camera, which was perceived by most to be purely mechanical, could be elevated to the "spheres of art." Anyone who not only sold photographs at exhibitions—obtaining prices as high as possible was a proof of the legitimacy of one's "existence as an artist" and hence worthwhile—but also produced commissioned portraits, for example, was suspected of betraying the cause.

Anonymous, *Hans Watzek, Heinrich Kuehn, and Hugo Henneberg on Lake Garda*, 1897, after original negative

Heinrich Kuehn may be considered a typical example of the *Bildungsbürger*. Born in 1866, the son of a wealthy merchant in Dresden, he was able to finance his studies of science at various universities and later his passion for photography from his private wealth—whose later loss he would never overcome. As he always emphasized, he had dealings with artists already as a child among his relatives, and later, after moving to Innsbruck, regularly attended the exhibition of old and modern masters, especially at the Munich and Vienna Secessions. He owned a camera early on, though his first serious engagement with photography began around 1888, when he took microscopic photographs for diagnostic purposes at the school of medicine in Innsbruck. Then he began to photograph his extended mountain tours and publish his first photographs and texts.[9]

In 1891 he met a member of the Wiener Camera Club for the first time, and then in 1895 he became a member himself, traveling to Vienna at irregular intervals. Alfred Stieglitz, who had met members of the club during a visit to Vienna in 1890,[10] was able to benefit in person from his membership even less frequently. It was, however, quite common, and was regarded as a distinction, to be voted a corresponding member of one of the important associations of amateur photographers. This led to an international network that permitted constant exchange of photographs and ideas.

THE WIENER CAMERA CLUB AND THE VIENNA SECESSION

The makeup of the Wiener Camera Club is noteworthy: it included men such as Nathaniel von Rothschild and Philipp von Schoeller—both from among the richest families of bankers and industrialists in the Habsburg monarchy—with less wealthy, but still quite well off, men such as Hugo Henneberg and Friedrich Viktor Spitzer. Its members also included the painter Hans Watzek, who had trained at the academies in Leipzig and Munich and earned his living teaching drawing at a secondary school, and the physicist, mathematician, and philosopher Ernst Mach, whose research (in part conducted using photography as a recording technique) in the field of the speed of sound brought him world fame. In keeping with the ideals of the *Bildungsbürgertum*, artists and scientists could achieve social status that blurred actual economic differences. It was thus a gathering of a selection of the elite of Austrian society, and it is an unusual feature of the Camera Club that from the outset it had women among its members. Its patron was Archduchess Maria Theresa, a close relative of Emperor Franz Josef.

The above-mentioned exhibition of art photography in 1891 and its new rules was a sign of a will to change in keeping with the much broader sense of a new era beginning in the arts, whose most famous manifestations were the establishment of the various Secession movements in Europe (in Munich in 1892, in Vienna in 1898, in Berlin in 1899). But it also led to the adoption of ideas from the Arts and Crafts movement, which resulted in far-reaching reform efforts on the European continent. There was a turn against salon painting and the historically decorated object was called a lie because it did not do justice to the time and to the material. The aesthetics of photography seemed to have degenerated in the hands not only of professional

Promotional postcard for the Vienna Secession, color lithograph after a motif by Joseph Maria Olbrich, sent to Heinrich Kuehn by Ludwig David, Hugo Henneberg, Fritz Matthies-Masuren, and Hans Watzek, December 31, 1898. Private Collection

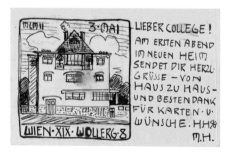

Friedrich Viktor Spitzer, *Josef Hoffmann*, 1904. Reproduction from: *Photographische Kunst im Jahr 1902*

Drawing by Hugo Henneberg, showing his house by Josef Hoffmann on the Hohe Warte, sent to Heinrich Kuehn on the occasion of moving into the house in May 1902, ink on paper. Private Collection

photographers but also of the ambitious hobby photographers and could no longer satisfy the higher demands for quality of elite arts enthusiasts, and revitalization seemed the obvious solution. It is thus scarcely surprising that the premises of the club were furnished in a modern and elegant style and that its house journal was carefully edited. This was quite in keeping with the ideal of a society that pursued a "strategy of taste that ennobles everything," extending from the design of everyday environments to clothing.[11]

At the Camera Club, Heinrich Kuehn quickly connected with Hugo Henneberg and Hans Watzek and later with Friedrich Viktor Spitzer as well. All three were closely associated with the artists in the group that founded the Vienna Secession. Those artists paid tribute to the artistic efforts of the Kleeblatt (Cloverleaf) or Trifolium, as the friends referred to themselves,[12] by publishing photographs by them in the journal *Ver Sacrum* in 1898, the first year it was published. In 1902 the artists' association exhibited photographs by the Kleeblatt in its new building on Karlsplatz, designed by Joseph Maria Olbrich. Their colleagues of the Munich Secession had preceded them in 1898 with a first presentation of art photographs in its spaces.[13]

Subsequently several important advocates of Viennese modernism, such as Hugo Haberfeld, Ludwig Hevesi, Joseph August Lux, and Adalbert Franz Seligmann, championed art photography in their journalism.[14] They argued for photography's status as an art as part of the Secession's efforts to achieve a complete renewal, often by comparing it to the achievements of the applied arts, which it valued highly as well. The applied arts also rejected "machine" production and preferred the elaborate manual procedures that would later be found in the work of the Wiener Werkstätte.

Hugo Henneberg and Friedrich Viktor Spitzer also participated in a project initiated by the architect Joseph Maria Olbrich to create an artists' colony on the Hohe Warte in Vienna, and in 1902 they moved into houses there designed by Josef Hoffmann. Their neighbors were the painter and interior designer Koloman Moser and the painter and entrepreneur of the arts Carl Moll, both of whom were founding members of the Vienna Secession.[15] When necessary, the Künstler-Kolonie (Artists' colony) also served as regular accommodations for foreign artists and art critics frequenting the exhibitions at the Vienna Secession. Carl Moll in particular indefatigably hosted all the forces of the avant-garde Vienna, and Gustav Klimt and Josef Hoffmann were as regular visitors there as Gustav Mahler (who met his future wife, Moll's stepdaughter Alma Schindler, there). When there was not enough room, they would move to the Hennebergs, where Heinrich Kuehn was a regular guest.

They also took trips together, for example in 1898 when Henneberg and Kuehn were in Venice with the influential German exhibition organizer and magazine publisher Fritz Matthies-Masuren, whom Alfred Stieglitz also highly esteemed as an author. They met the Molls and Gustav Klimt there as well.

In the homes on the Hohe Warte, Hoffmann had not only earmarked space for the owners' photographs; paintings and photographs were hung on the wall as equals—in Henneberg's case, for example, his own photographs were juxtaposed with Klimt's portrait of Henneberg's wife,

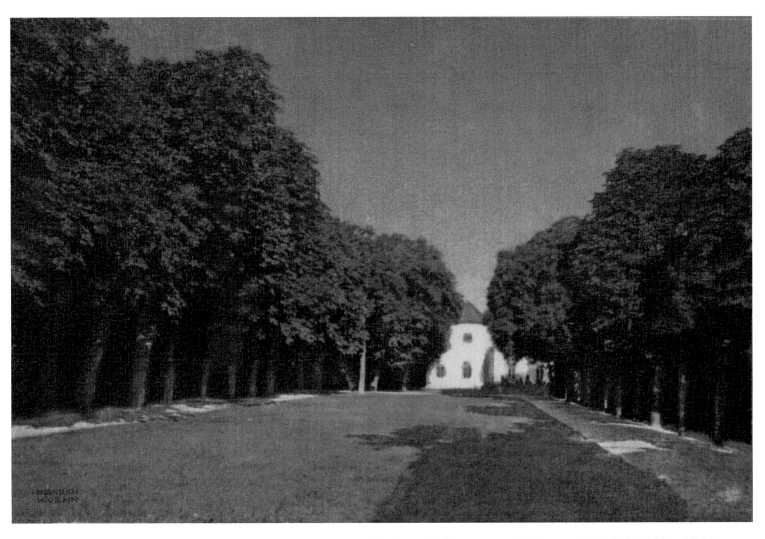

Heinrich Kuehn, *Nymphenburg Castle*, 1900, gum bichromate print, 32.4 x 47 cm (12 ¾ x 18 ½ in.). The Museum of Modern Art, New York. Gift of Edward Steichen

Marie. In Moll's home a photograph by Kuehn could be seen right next to works by Paul Gauguin or Vincent van Gogh—whom he also presented for the first time Vienna, initially as exhibition organizer for the Vienna Secession and then as director of the avant-garde Galerie Miethke. Galerie Miethke presented several Camera Club exhibitions, for which Koloman Moser and the graphic designer Emil Orlik sat on the selection committee and Stieglitz chose the American participants. In 1907 Moll had an exhibition of Heinrich Kuehn's works together with Friedrich Viktor Spitzer, immediately before an exhibition by Gustav Klimt.

Carl Moll, *Study*, ca. 1903, oil painting, whereabouts unknown; a large gum bichromate print by Hugo Henneberg and *Twilight/Dämmerung* of 1896 by Heinrich Kuehn on the wall

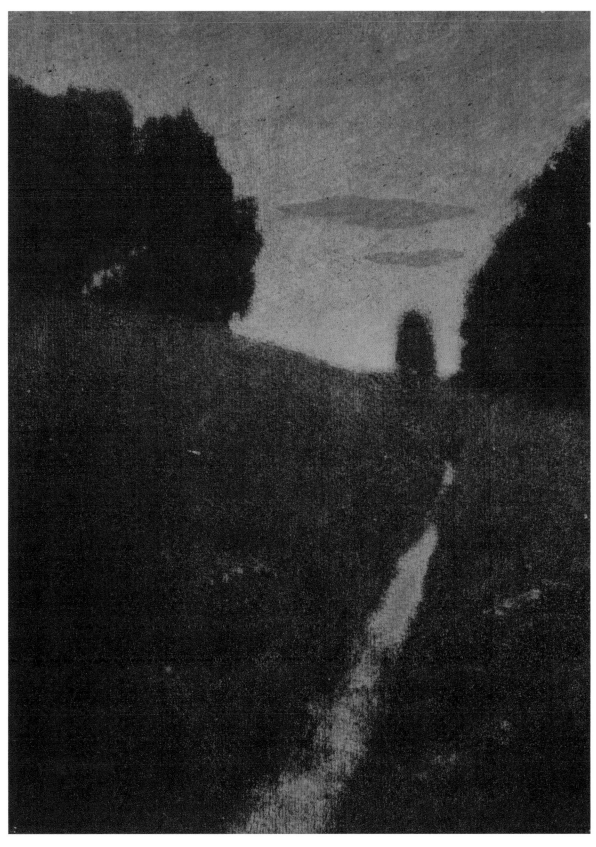

Heinrich Kuehn, *Twilight/Dämmerung*, 1896, bi-color gum bichromate print (partly painted in watercolor), 38 x 27.3 cm (15 x 10 ¾ in.).
Albertina, Vienna

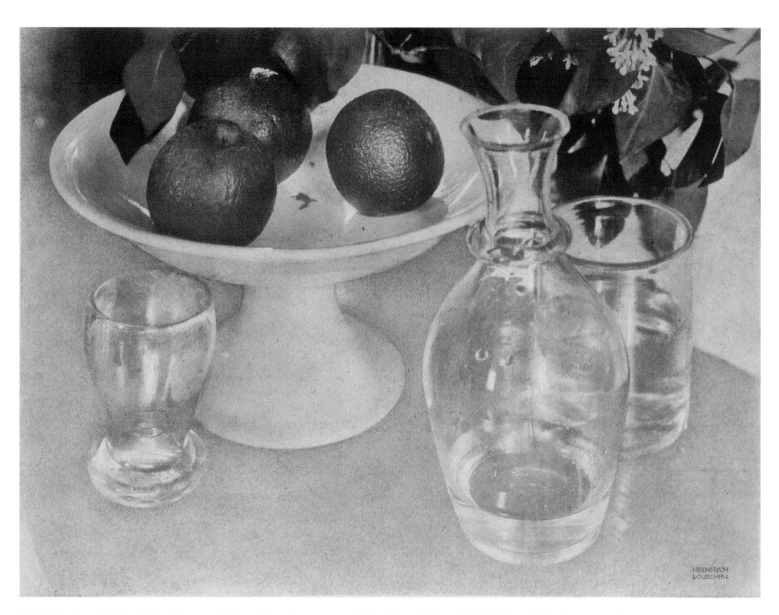

Heinrich Kuehn, *Still-Life with Fruit Bowl*, ca. 1909, multiple oil transfer print, 29.3 x 39 cm (11 9/16 x 15 3/8 in.). Private Collection, Innsbruck

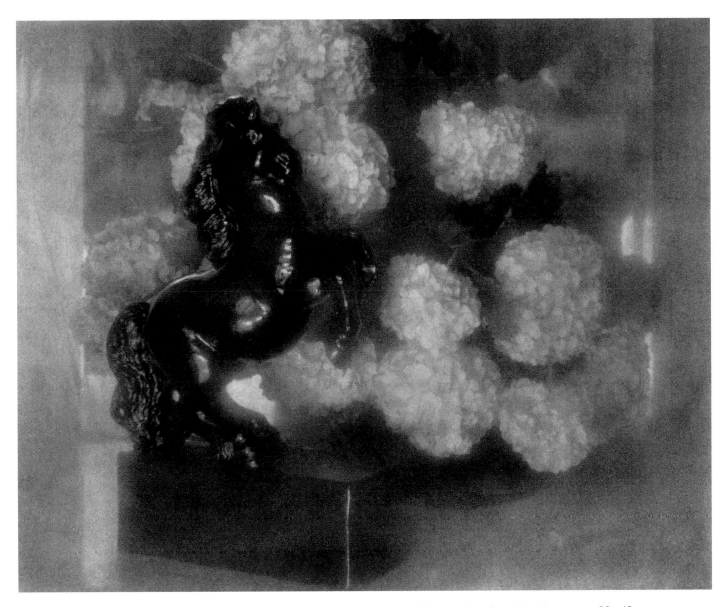

Heinrich Kuehn, *Still-Life with Horse and Flowers/Stillleben mit Pferd und Blumen*, ca. 1914, bromoil transfer print on tissue paper, 30 x 40 cm (11 ¾ x 15 ¾ in). Galerie Kicken Berlin. © Estate of the Artist/Galerie Kicken Berlin

Photographer unknown, Spitzer House with interiors designed by Josef Hoffmann, ca. 1904, with photographs on the wall by Spitzer

Heinrich Kuehn, Walther and Hans in the studio of the Kuehn Villa, Innsbruck, ca. 1906, after original negative

When Kuehn had the "first house in the Hoffmann style" built in Innsbruck in 1904,[16] he followed in many details the model of his friends, from the furniture to the fabrics to applied arts from the Wiener Werkstätte. His wife, Emma Kuehn, also tried out the latest fashions and wore reform clothing without corsets like Klimt's partner, Emilie Flöge, although she preferred much simpler styles. Later Kuehn used Turkish paper from the Wiener Werkstätte for the boxes he had made for his autochromes. All of this is the backdrop against which his efforts toward a renewal in his own area of interest, photography, could be seen.

The role of the cultural trailblazer could not have been articulated without constant reference to less innovative circles, even within his own amateur movement. Kuehn became almost obsessed with the idea of recruiting only the "best" photographers from each country for an international association of the elite, since in his view many members of the Camera Club did not take their work seriously enough—and did not pursue it radically enough. Perhaps the many discussions in the Künstler-Kolonie on the Hohe Warte about disagreements within

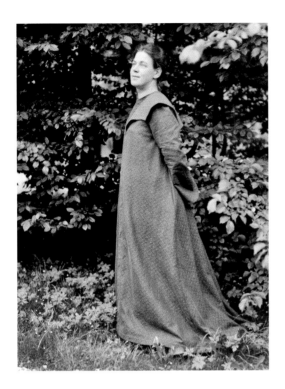

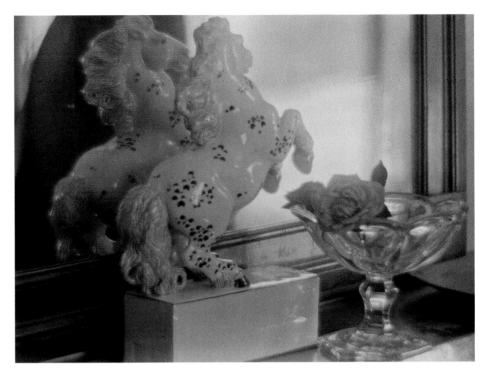

the Vienna Secession, which in 1905 would culminate in the resignation of the "Klimt group" (including Carl Moll), had inspired the photographer. Kuehn found a like-minded spirit in Stieglitz, who with his Photo-Secession in New York had already orchestrated an exodus from the New York Camera Club, with whom he could pursue this idea of an "international association of art photographers."[17] From 1904 to 1909 they would together make the selections for several international photography exhibitions that advocated their rigorous ideas.

Heinrich Kuehn, *Emma Kuehn wearing a Reformkleid* (reform dress), 1902, after original negative

Heinrich Kuehn, *Still-Life/Stillleben*, ca. 1908, after original negative. The ceramic horse was designed by Michael Powolny. Kuehn used it in many images, sometimes painted in black if it better suited his compositions.

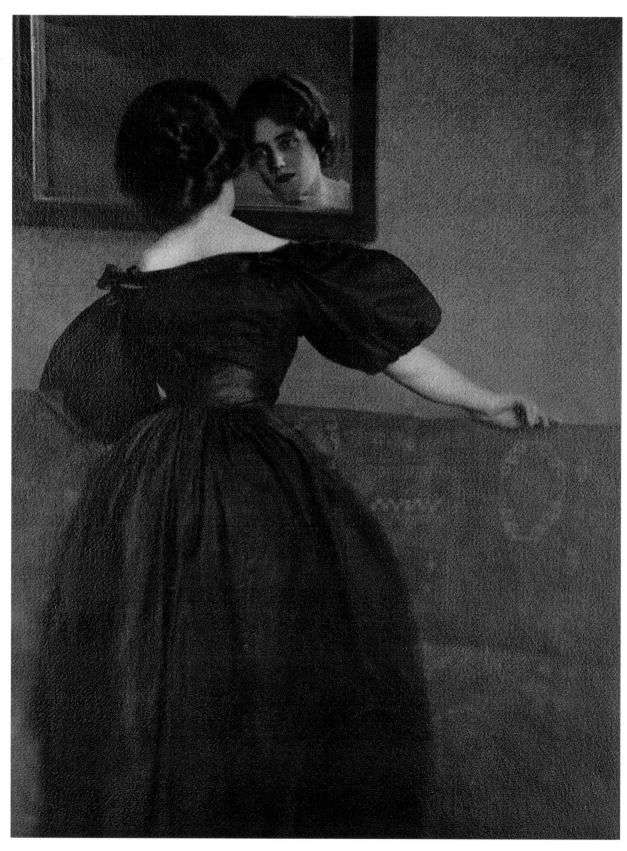

Heinrich Kuehn, *Anna with Mirror/Anna mit Spiegel*, 1902, gum bichromate print, 77 x 59 cm (30 ¼ x 23 ¼ in.). Private Collection

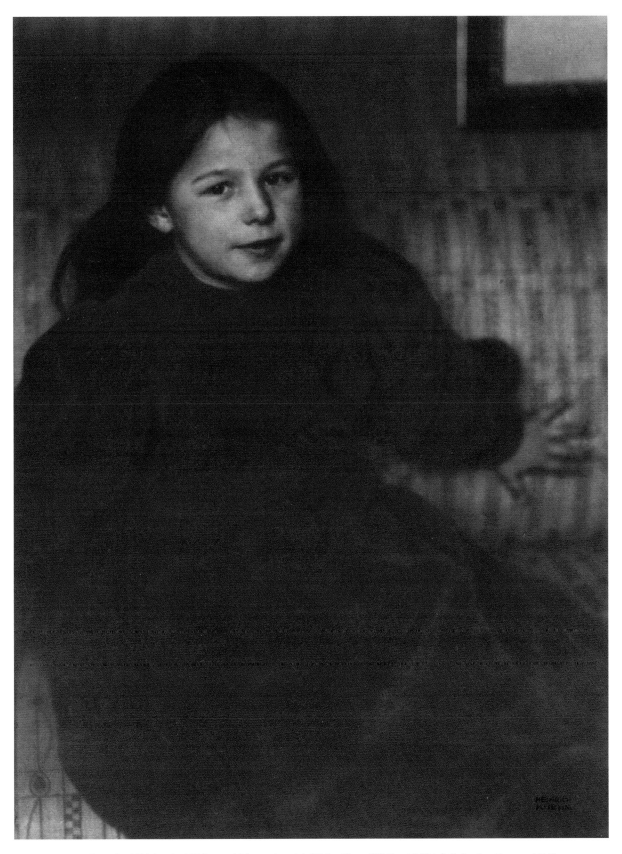

Heinrich Kuehn, *Portrait of Edeltrude*, 1906, gum bichromate print, 52.4 x 40 cm (20 ⅝ x 15 ¾ in.). Collection Raymond E. Kassar, Courtesy Cheim & Read, New York

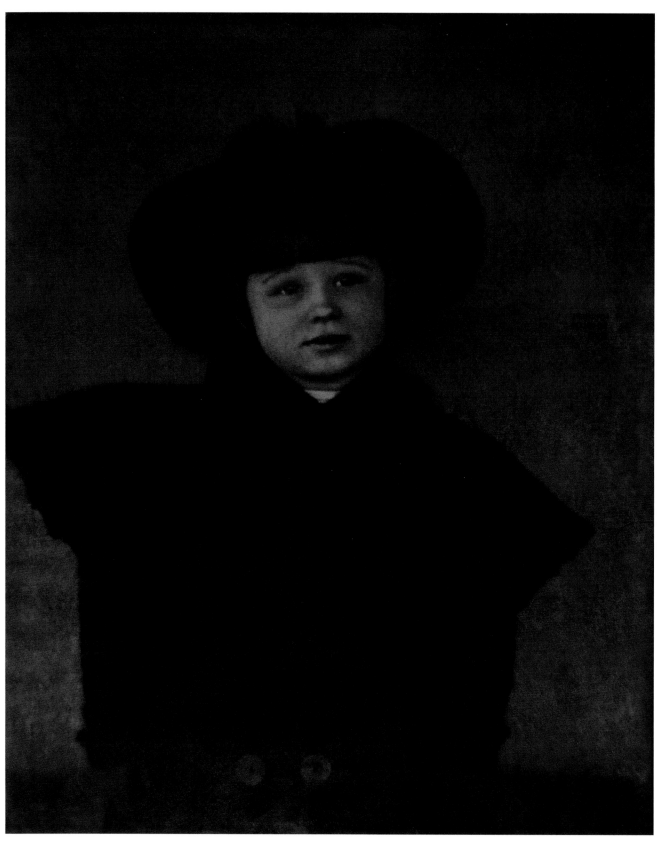

Heinrich Kuehn, *Hans Kuehn*, 1900, gum bichromate print, 68.6 x 55.9 cm (27 x 22 in.). Collection Raymond E. Kassar, Courtesy Cheim & Read, New York

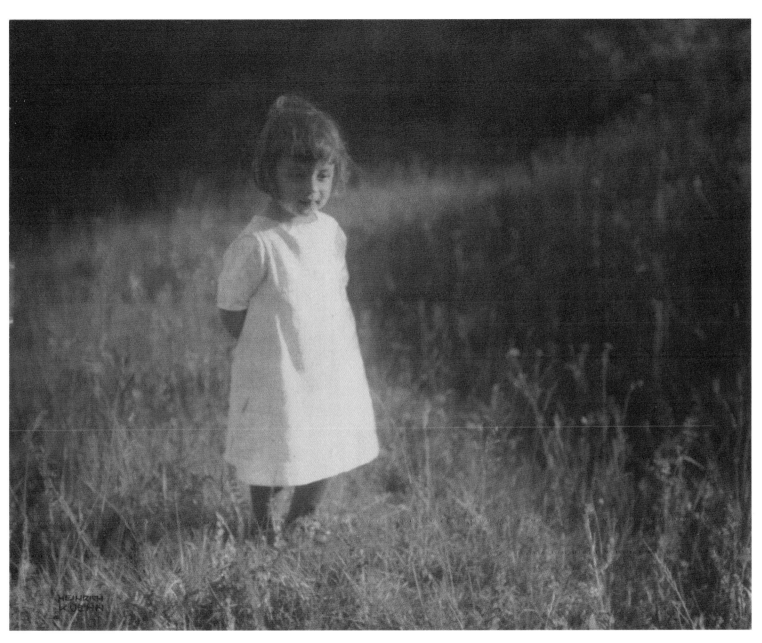

Heinrich Kuehn, *Hans in the Summer Meadow/Hans auf der Sommerwiese*, photograph 1902, print February 1903, ozotype, 55.9 x 68.2 cm (22 x 26 ⅞ in.). Photoinstitut Bonartes, Vienna

ATMOSPHERIC PHOTOGRAPHS

Anyone seeing one of the great early landscapes by Heinrich Kuehn for the first time will doubt it is truly a photograph. His contemporaries were struck above all by their extraordinary format, yet by the end of the twentieth century—once again in connection with photographs in an art context—we have grown accustomed to that. What we perceive as missing is the rich detail of ordinary photographs and above all the characteristic smoothness of surfaces. They remind us more of prints, yet this particular effect could not be achieved by any painting or printing technique.

The photograph that Kuehn described in retrospect as his first "art photograph" has survived. It is a platinum print titled *Innsbruck, Dezember 1894*, and it is clearly distinct from the conventional landscapes from the period that preceded it. The recognizable location—for example,

Heinrich Kuehn, *Innsbruck, December 1894/ Innsbruck, Dezember 1894*, platinum print, 19.8 x 15.3 cm (7 ¹³⁄₁₆ x 6 in.). Private Collection

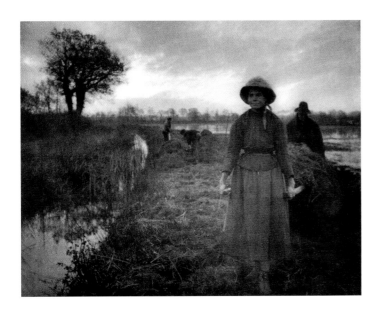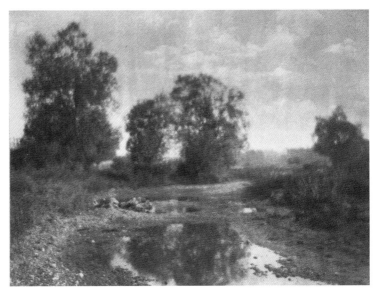

motifs from Lake Garda or views of the city of Innsbruck—has given way to an unspectacular, relatively narrow slice of nature. Snow-covered grass and underbrush extend into the depth; the horizon is delimited by leafless trees.

With this photograph, Kuehn entered into a precisely definable artistic milieu that makes it possible to identify both photographic influences and connections to contemporaneous painting. The date proves that it was taken after his first encounters with Henneberg and Watzek. The models for the intimate landscapes of those Viennese photographers were English photographs that for some time had been exhibited regularly at the Camera Club.[18] This group was familiar with Peter Henry Emerson's theses from his influential book *Naturalistic Photography for Students of the Art* (1889), which, on the one hand, settled accounts with the usual staged and retouched photographs. On the other hand, Emerson followed the German physiologist Hermann von Helmholtz in distinguishing between mechanical and human perception: Emerson attributed the term "realistic" to the thorough precision of photographs taken with a correcting camera lens. To reproduce human vision, which does not perceive the entire field of vision as equally sharp, as faithfully as possible, photographs should not be sharp everywhere. Emerson called photographic images that recreate the personal impression of the eye with its momentary atmosphere "naturalistic." "Atmosphere is the medium through which we see all things. In order, therefore, to see them in their true value on a photograph, as we do in Nature, atmosphere must be there. Atmosphere softens all lines; it graduates the transition from light to shade; it is essential to the reproduction of the sense of distance. That dimness of outline which is characteristic for distant objects is due to atmosphere."[19]

"Atmosphere" is, however, a term very closely connected with painting of this period in the German-speaking world, such as the landscapes of Jakob Emil Schindler, Rudolf Ribarz, Robert Russ, and Marie Egner.[20] Reviews of these artists frequently use the expression "natural

Peter Henry Emerson, *Poling the Marsh Hay*, 1886

Heinrich Kuehn, *Near Dachau*, ca. 1895, platinum print, 28.3 x 38.3 cm (11 ⅛ x 15 ⅙ in.). Private Collection

Jakob Emil Schindler, *River Meadows at Hacking*, 1880, oil painting. Current whereabouts unknown

atmosphere" or discuss the "magic of the tone and the atmosphere" in order to describe the new appeal of their landscapes in contrast to landscapes produced in keeping with the doctrines of the academies. Later these artists' works were categorized as "atmospheric realism" or "atmospheric impressionism."[21]

The decision to model his work on such "atmospheric paintings," which were indebted to the ideas of French Impressionism but also to the Worpswede and Dachau schools of painters, represented a turning point in Heinrich Kuehn's life.[22] A pleasant leisure activity became *the* driving force of his life. It is by no means contradictory that this coincided with a change in the circumstances of his life, from unsteady student to wealthy man of independent means and artistic ambitions. Motifs from a recently established current in painting were employed to fight a battle on another field, namely, making photography a subjective and individual—that is, "artistic" in the sense of that period—form of expression. These intimate landscapes in painting and photography struck "a nerve of the era."[23] Exponents of an urban upper middle class found here an ideal alternative world in romanticized patches of nature.

Daring themes borrowed from painting—intimate excerpts of landscapes as they are transformed by the seasons or the hours of the day—represented an extraordinary technical challenge. Not only did photographers lack any way to depict shades of color but it was also practically impossible to depict sky, clouds, or the reflective surfaces of bodies of water in a way that approached the impression they made on the eye; in other words, there was no way to produce the sought-after "natural atmosphere" celebrated by painters. Hence ambitious amateurs regarded the usual photographic methods as falsifying and mindless routine. They missed the naturalistic, "subjective visual image" familiar from painting, with its inherent "inner truth."[24] In 1907 Fritz Matthies-Masuren summarized the principles of art photography in a retrospective summary: "The genuine goal, so as not to lose sight of it, in these efforts is the reproduction of atmospheres—as opposed to expressionless views—artistic impressions of nature that cannot result from a uniformly sharp and indifferent rendering of the objects in the image."[25] Alfred Stieglitz distinguished between "photographs" and "pictures" to express the same antithesis.[26]

The platinum print, which had already been praised by P. H. Emerson and permitted more subtle gray tones than the gelatin-silver print, coarser papers, and Hans Watzek's uncorrected monocular lens made it possible to produce photographs that satisfied these demands for blurriness produced by genuine photography. That was also the reason behind Hugo Henneberg's advocacy of the use of paper negatives (rather than industrially produced glass plates), whose soft-focus effects had been regarded as distracting in the early days of the technology.[27]

DECORATIVE EFFECT

In 1895, however, examples of a revolutionary new technology caused a stir at the Camera Club.[28] Robert Demachy's gum bichromate prints were closer to traditional graphic techniques than to conventional photographs. Indeed, the positive copy of the photograph was no longer produced by the traces of silver salts blackened by exposure to light. What one saw instead were

color pigments dissolved in a mixture of a tincture of gum arabic and photosensitive chromate salts and then fixed by the effects of light. Hence gum bichromate prints naturally lacked the characteristics originally associated with photography. If one wished to bring photographs closer to what people were accustomed to recognizing as the products of artistic creativity—charcoal and red chalk drawings, for example—this technique opened up a new, desirable path. According to one critic at the Wiener Camera Club, it requires "less imagination, in fact, to take [these works] to be gouache paintings than it does to imagine that these effective pieces owe their existence entirely to purely photographic methods."[29]

Heinrich Kuehn immediately took up experimenting with the new technique and engaged in a lively exchange with Hans Watzek and Hugo Henneberg regarding it. The crucial advantage of the gum print was the great freedom of artistic possibilities, though they could only be mastered with a great deal of practice. First, there were no limitations in the choice of the color of the print—virtually any pigment could be used. By repeating the copy process several times under altered conditions or with different pigments, the gradations of color nuances and brightness values within the image could be controlled and influenced precisely as desired. Second, all of the details registered by the camera were necessarily lost: the pigment particles bound in the photosensitive salts were distributed according to the brightness and darkness values of the negative, but they had not clear outlines. The coarse paper produced an open structure that recalled the effects of an Impressionist painting style.

Hans Watzek, *Landscape*, 1901, multi-colored gum print, 40 x 59 cm (15 ¾ x 23 ⅝ in.). Private Collection

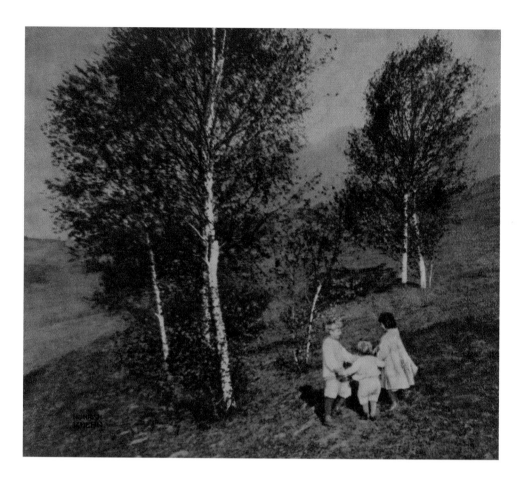

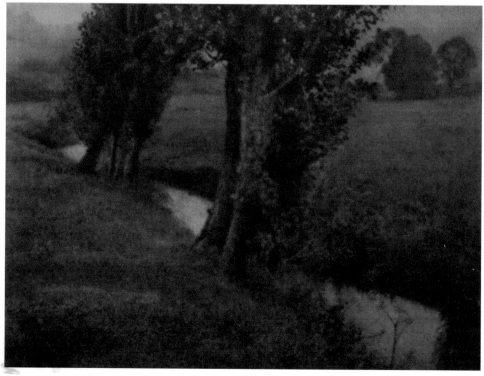

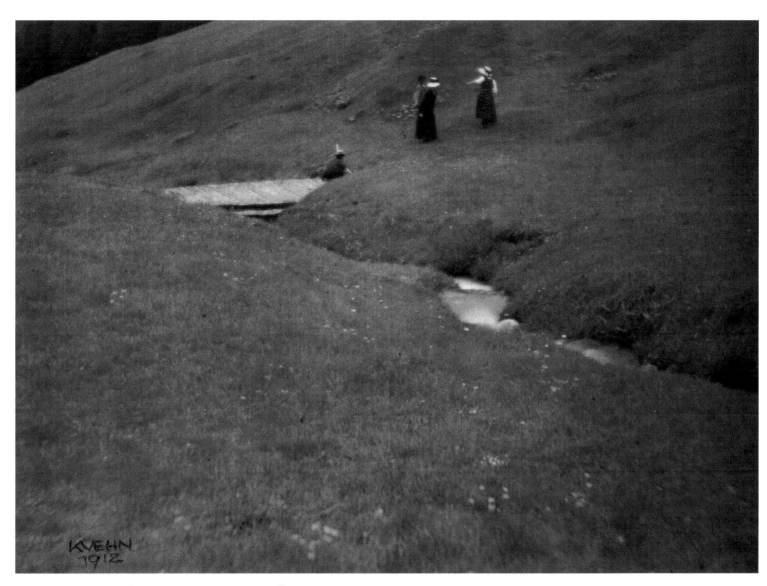

Heinrich Kuehn, *Hikers in a Meadow*, ca. 1912, autochrome. Österreichisches Nationalbibliothek, Bildarchiv, Vienna

Opposite:
Heinrich Kuehn, *Three Children in a Landscape*,
ca. 1902, gum bichromate print, 54.6 x 62.2 cm
(21 ½ x 24 ½ in.). The Noel and Harriette Levine
Collection, at The Israel Museum, Jerusalem,
repro photo by Anthony Troncale and Arturo Cubria,
New York for The Israel Museum, Jerusalem

Bottom:
Heinrich Kuehn, *Landscape*, duplex half-tone
reproduction from *Camera Work* no. 33, 1911,
14.6 x 19.3 cm (5 ¾ x 7 ⅝ in.).
Photoinstitut Bonartes, Vienna

Gustav Klimt, *Orchard/Obstgarten*, 1898, oil on board, 39 x 28 cm (15 ⅜ x 11 in.). Private Collection, Vienna

Heinrich Kuehn, *Setting Sun/Abendsonne*, before 1902, gum bichromate print, 27.4 x 45.8 cm (10 ¾ x 18 in.). Private Collection

Several suggestions were made to coin other terms than "blurry" for such tonally gradu-ated areas of pigment. Kuehn himself spoke of "raw" prints or of "open areas of color." In Berlin the term "primitive" was used on the occasion of the first presentation of such prints, a term that was also common in descriptions of the techniques of Paul Cézanne and Paul Gauguin. Matthies-Masuren later recalled: "The first gum prints we encountered in Germany were works by Heinrich Kuehn at the Berlin exhibition in 1896. […] In the peace of our exhibition, in the rela-tively tame discussion of the new goals of art photography, Kuehn's contribution exploded like a bomb—I cannot describe the impression any other way. But it was not just the technique that met with opposition. The bold rigor with which the primitive quality of the technique had been exploited to produce Impressionist studies in the spirit of modern art met with equally strong resistance."[30] The "modern art" of which Matthies-Masuren spoke no longer meant the delicate works of the "atmospheric impressionists" but the much more planar works of the members of the Munich and Vienna Secessions. Like the forms of the details, the pictorial composition as a whole was reduced by means of close-ups and tight framing.

The deep spatiality of the earlier prints disappeared in favor of details of landscapes that seemed to have molded into the picture plane. The model here was the Japanese woodcut, which had become familiar primarily thanks to the Munich art journal *Die Jugend* and was col-lected by several of the amateurs. The young Viennese painters also paid tribute to this pre-cursor; Gustav Klimt in particular, whose study *Obstgarten* (Orchard) of 1898 is very close to Kuehn's *Wiese mit Bäumen* (Meadow with Trees) from the previous year. Both of them used a viewfinder for their landscapes: a piece of cardboard with a square or rectangle cut out to test the effect of a detail before the natural motif itself. The peculiar spatiality of these works permits a second hypothesis, namely, that Kuehn was experimenting with the telephoto lens that had

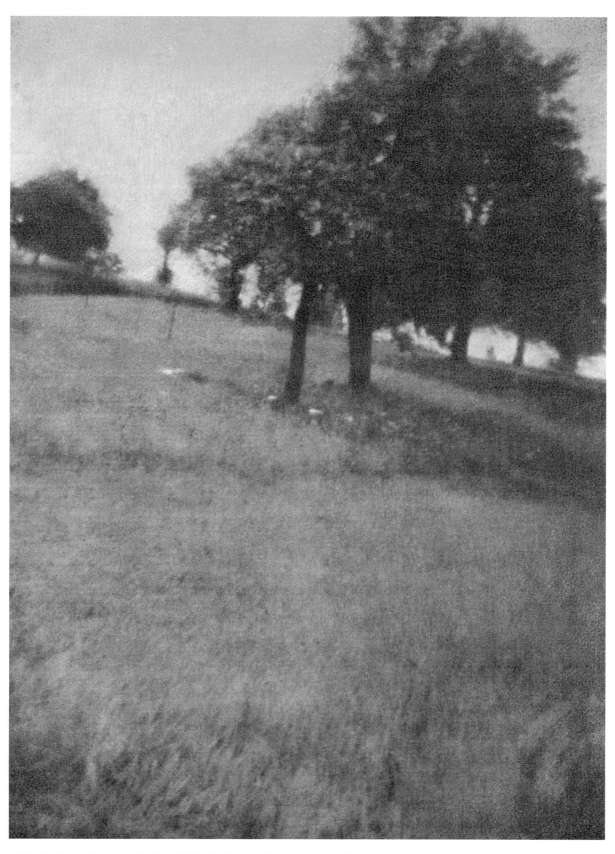

Heinrich Kuehn, *Meadow with Trees*, 1897, tri-color gum bichromate print, 37.9 x 27.8 cm (14 $^{15}\!/_{16}$ x 10 $^{15}\!/_{16}$ in.). Private Collection

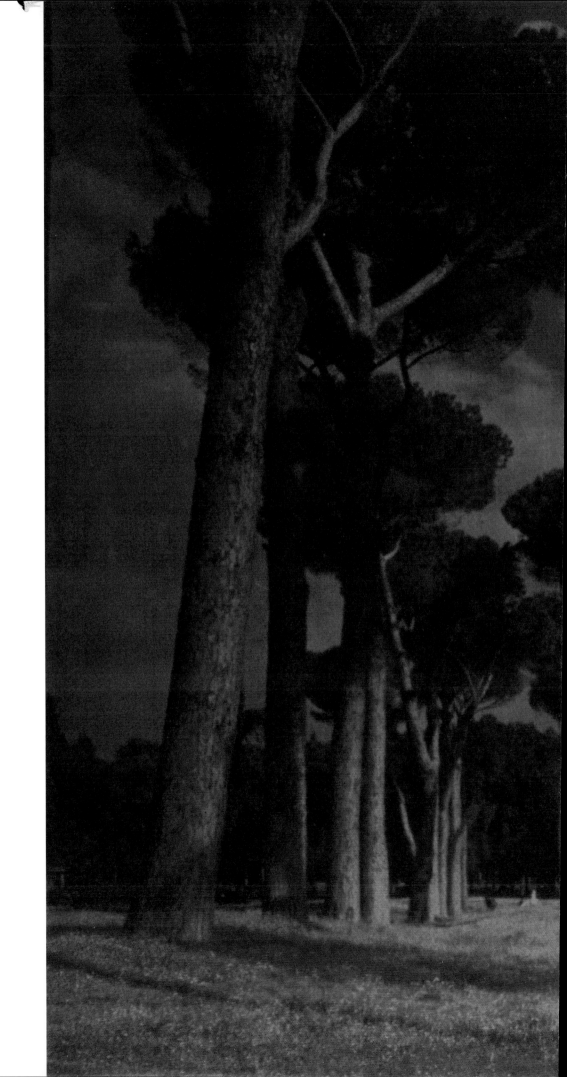

Heinrich Kuehn, *Roman Villa/Römische Villa*,
1898–1900, gum bichromate print, 55.8 x
74.5 cm (22 x 29 5/16 in.). The Metropolitan
Museum of Art, Alfred Stieglitz Collection, 1933
(33.43.408). © Estate of Heinrich Kuehn/
Courtesy Galerie Kicken Berlin

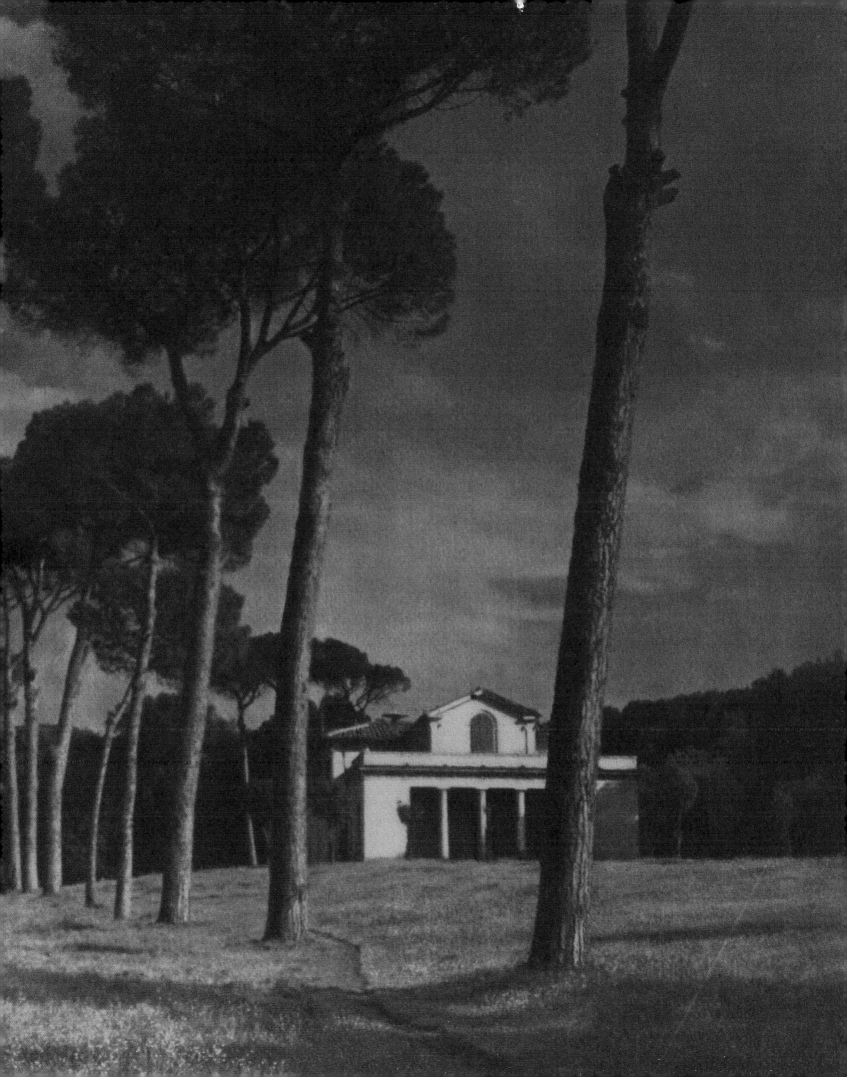

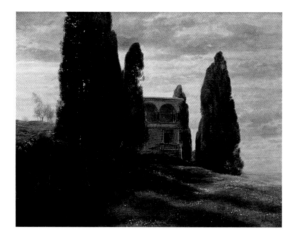 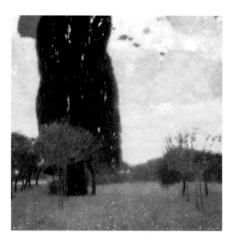

Arnold Böcklin, *Italian Villa/Italienische Villa*, 1870–71, oil on canvas, 125 x 175 cm (49 ¼ x 68 7/8 in.). Bayrische Staatsgemäldesammlung, Munich

Gustav Klimt, *The Tall Poplar Tree I/Die Grosse Pappel I*, 1900, oil on canvas, 80 x 80 cm (31 ½ x 31 ½ in.). Private Collection, New York

Opposite:
Hugo Henneberg, *Italian Villa in Autumn/ Italienische Villa im Herbst*, 1898, gum bichromate print, 54 x 74.5 cm (21 ¼ x 29 5/16 in.). The Metropolitan Museum of Art, Alfred Stieglitz Collection, 1933 (33.43.411)

Heinrich Kuehn, *Southern Landscape/ Südliche Landschaft*, 1898, gum bichromate print, 55.5 x 77 cm (21 7/8 x 30 ¼ in.). Private Collection

just come onto the market and had been used effectively by several art photographers. Its use by Kuehn for several cityscapes has been documented.[31]

A similarly reduced spatiality, but now in the ca. 60 x 80 cm (23 5/8 x 31 ½ in.) format that had dominated his work since 1898 but was unusual for the time, is seen in Kuehn's *Südliche Land-schaft* (Southern Landscape), which also reveals how strikingly close the motifs of Kuehn and his friends were to those of Gustav Klimt. Their work is also comparable in terms of the monumental-ization of the composition, which in the photographs is achieved by making the individual pictorial elements uniform with just a few intensely saturated variations of color—an effect impossible in any technique other than the gum print.

The model for all of them was Arnold Böcklin, whose work was shown several times in the Munich and Vienna Secessions. Kuehn admired him greatly and liked to cite from his diary: "The decorative is not a secondary matter in art but one of its most important."[32]

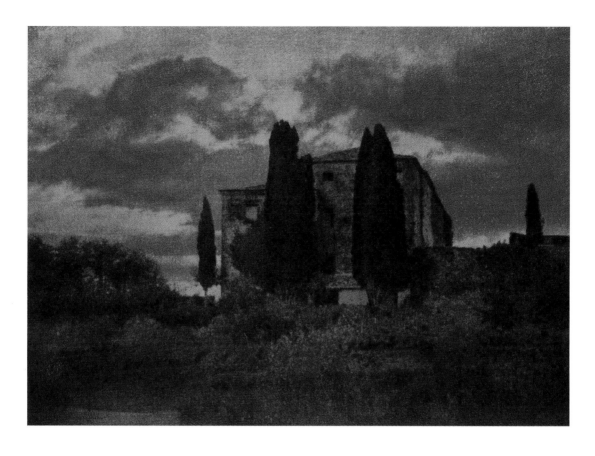

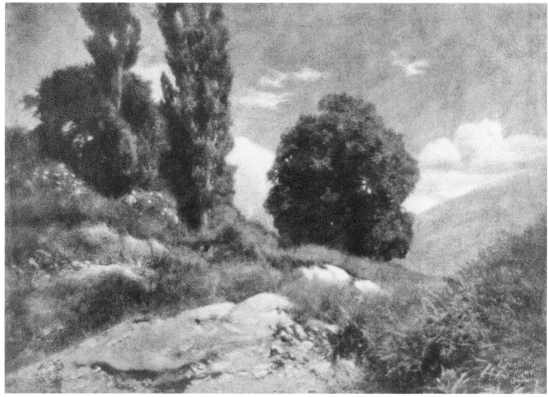

ARTISTS RATHER THAN AMATEURS

This category of the decorative seen as purely positive, which was now claimed for photographs as well,[33] helped images from the camera to obtain a dominating effect on the wall of exhibition spaces for the first time. That gave them the legitimacy to compete as a genre equal to painting and the graphic arts for the first time. This was acknowledged in art journals for the first time as well: "Thanks to its recent adoption of the method of gum printing, amateur photography has escaped the purely athletic treatment to which it had often succumbed previously and been elevated to an artistic sphere," read *Ver Sacrum*.[34] And the writer Peter Altenberg noted: "The modern photograph has become so much more important as a result of the astonishing gum printing technique that it is now an autonomous art form."[35] Vasily Kandinsky was particularly enthusiastic, regarding "Symbolist photography as a related, or perhaps allied form of expression" to painting.[36]

Alfred Stieglitz also welcomed the introduction of the gum print: "For by means of this method the artist has at last found an unlimited means of expression. A new field of possibilities has been opened to him, and the prospects for the future of pictorial photography have become much brighter with this advent. Gum printing is bound to revolutionize pictorial photography."[37] He defended the technique against those who claimed it strayed too far from the original path of photography: "Gum prints have been condemned as illegitimate by many who do not seem to understand how they are produced. The writer is a strict believer in the legitimate, for he has never retouched a negative or print, and yet he claims that gum printing is as legitimate as

Edward Steichen, *The Big White Cloud, Lake George*, 1903; this print ca. 1960s, gelatin silver print, 27.9 x 35.5 cm (11 x 14 in.). Courtesy Bruce Silverstein Gallery, New York. Permission of the Estate of Edward Steichen. Heinrich Kuehn owned an early print of this image.

Opposite:
Heinrich Kuehn, *A Summer Day/Ein Sommertag*, 1898, gum bichromate print, 78.7 x 52.6 cm (31 x 20 11/16 in.). The Metropolitan Museum of Art, Alfred Stieglitz Collection, 1933 (33.43.278). © Estate of Heinrich Kuehn/ Courtesy Galerie Kicken Berlin

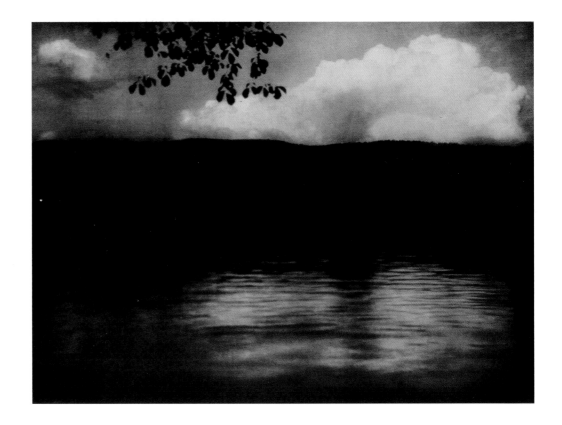

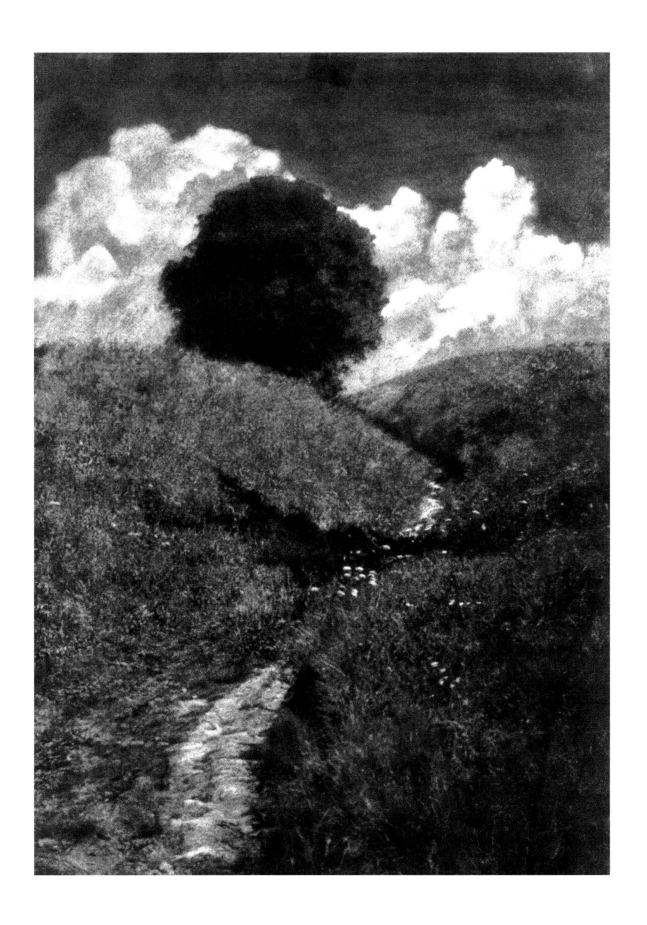

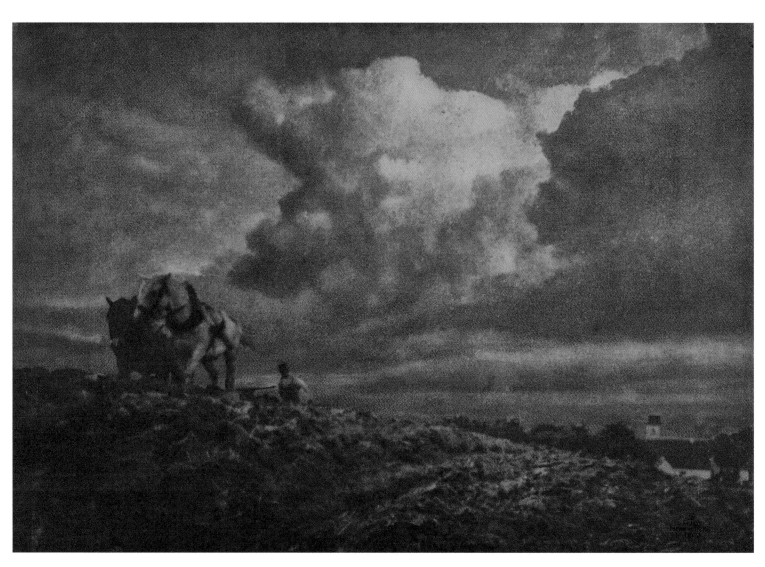

Hugo Henneberg, *Ploughman/Pflüger*, 1890–1901, printed 1903, gum bichromate print, 65.8 x 95.8 cm (25 ¹⁵⁄₁₆ x 37 ¾ in.). The Metropolitan Museum of Art, Alfred Stieglitz Collection, 1933 (33.43.413)

printing with aristo. Local treatment is possible in either, that there should be more latitude in the former method is only to its credit."[38] Hence it is not surprising that the majority of photographs Stieglitz showed in his first solo exhibition at the Camera Club in New York in 1899 were manipulated platinum prints or gum prints, some of which were in large formats. "Like other contemporary pictorial photographers—Heinrich Kuehn or Robert Demachy, for example—he utilized every tool available to transform these photographs into impressive exhibition pieces that would be immediately understood as works of art," wrote Sarah Greenough in her detailed analysis of Alfred Stieglitz's *Key Set*.[39] But whereas for Kuehn and his Viennese friends the gum print was considered the definitive solution for advancing photography to an artistic technique, allowing no alternative, Stieglitz remained more open: "We do not go so far as to advise pictorial photographers to discard all other methods of printing, for a beautiful picture in platinum or carbon remains a work of value, although it may not be quite so interesting as a photographic novelty to the photographer just at present."[40] Indeed, Stieglitz soon returned to the platinum print; nevertheless, in 1906 he devoted one of the first exhibitions at his new gallery on Broadway to the large-format gum bichromate prints of the Trifolium—not coincidentally, right after a solo exhibition of the works of Edward Steichen, who was by no means less passionate about technical experiments than the Viennese photographers were.

Heinrich Kuehn, *Alfred Stieglitz*, August 19, 1904, platinum print, 18 x 15 cm (7 ⅛ x 5 ⅞ in.). Private Collection

"The Steichen collection was followed by an exhibition of the work of the Viennese Trifolium, Mssrs. Kuehn, Henneberg, and Watzek (deceased), and of one print by the Germans, Theodore and Oscar Hofmeister of Hamburg […] This last collection represented one of the most interesting and important of the season's series. The bold strong work of the leading Viennese and German workers has always held a peculiar charm for their American co-workers—just as in the past their bold independent stand on behalf of interests of pictorial photography in spite of all ridicule and opposition had won the admiration of the Americans and influenced and inspired them in their own course. The pictures shown were nearly all comparatively large prints, which attracted attention, and the art-loving element of the city and many of the photographic body, till now not familiar with this work in the original, were very deeply and favorably impressed."[41] This commentary by Stieglitz's close associate Joseph Keiley makes the essential point: the large formats and "powerful" gum print—that is, the unphotographic surface—were convincing arguments for photography being granted the status of an art by broader circles. That was an argument for exhibiting them, even though Stieglitz was not the only one who had ceased making gum prints by then;[42] Heinrich Kuehn, too, was already experimenting with new directions.

Heinrich Kuehn, *Siegestor, Munich*, 1898–99, gum bichromate print, 54.6 x 75.6 cm (21 ½ x 29 ¾ in.). Photoinstitut Bonartes, Vienna

Heinrich Kuehn, *Winter Street*, ca. 1904, after original negative

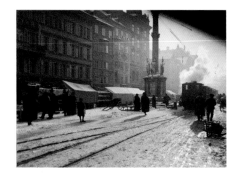

AUGUST 1904: THE TURNING POINT IN HEINRICH KUEHN'S OEUVRE

Presumably influenced by Secessionist graphic arts, the gum bichromate prints of Heinrich Kuehn and Hugo Henneberg became increasingly planar. The surface no longer featured the coarse, open structure of their early works but was reduced to a few fields of pigment that were almost entirely uniform. At the same time, Kuehn redoubled his efforts to extend the range of variation in tonal value by means of printing several thin layers of pigments on top of one another. With his monumental formats, however, he was reaching the technical limits of gum bichromate printing.

By this time Kuehn had already been working for years on portraits of his children in which this problem was manifested in a particular way: in order to achieve delicate gradations in the brighter areas of the gum print—faces and hands—the copying process had to be repeated three or four, even up to seven, times. But this resulted in a shiny, unstructured mass of pigment in the darker areas, giving the photographs a clumsy heaviness. A fundamental principle became clear: "The Viennese […] have learned how to simplify, to cover the plane with a boldness that never seemed possible previously by photographic means," wrote Eugen Kalkschmidt, an influential contemporary critic and fellow traveler of the Pictorialists. The result was a "decorative power of appearance […], but much of the subtlety of the Impressionist effect was lost." Kalkschmidt saw "that the danger of excessive contrast, of coarsening is greater as the enlargements chosen are increased."[43] Kalkschmidt came to this insight through a comparison with the

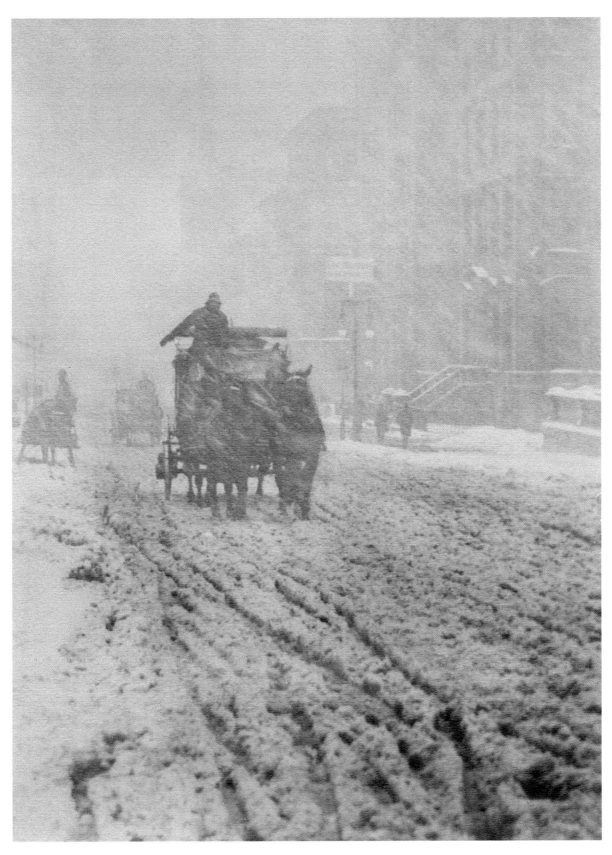

Alfred Stieglitz, *Winter, Fifth Avenue*, 1893, carbon print, 23.8 x 18.7 cm (9 ⅜ x 7 ⅜ in.). Collection of Randi and Bob Fischer.
Heinrich Kuehn previously owned this print. © 2012 Georgia O'Keeffe Museum/Artists Rights Society (ARS), New York

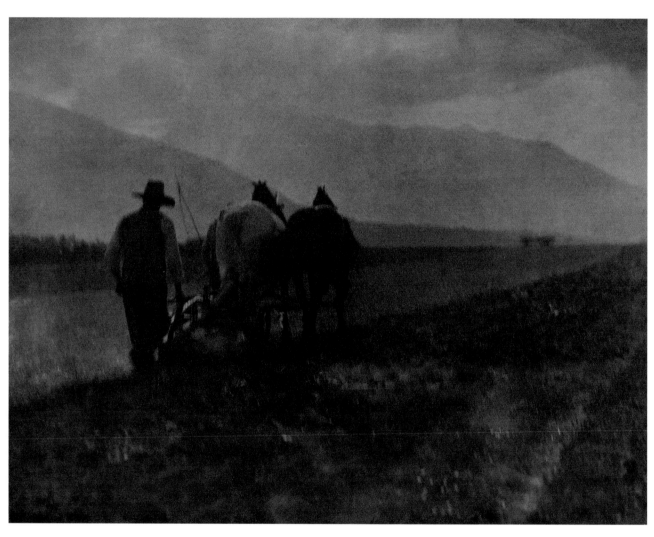

Alfred Stieglitz, *Ploughing*, photograph made in 1904, photogravure from *Camera Work*, no. 12, 1905, 19.1 x 24.1 cm (7 ½ x 9 ⁹⁄₁₆).
© 2012 Georgia O'Keeffe Museum/Artists Rights Society (ARS), New York

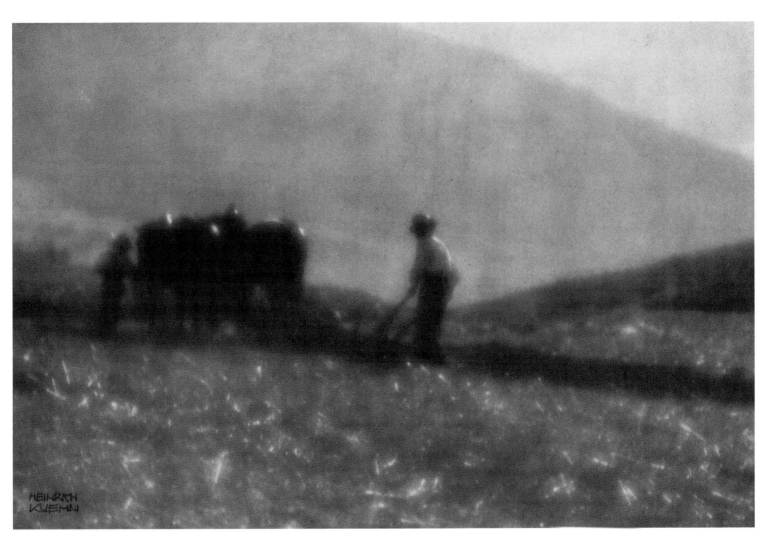

Heinrich Kuehn, *Ploughman/Pflüger*, 1904, platinum print, 25.9 x 38.3 cm (10 ⁹⁄₁₆ x 15 ¹⁄₁₆ in.). Courtesy of George Eastman House, International Museum of Photography and Film

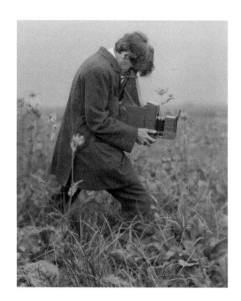

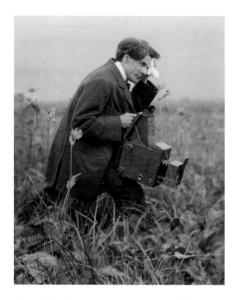

Alfred Stieglitz with Camera in Igls, 1904, after original negative

Alfred Stieglitz with Camera in Igls, 1904, after original negative

works of American art photographers, which were shown for the first time in large numbers in Germany and Austria in 1902, especially the works of Alfred Stieglitz and Edward Steichen.

Stieglitz, who was in Europe in 1904 for the first time in ten years, also noticed this contrast when visiting the *Internationale Kunstausstellung* in Dresden, right before meeting Kuehn: "What an opportunity to judge by comparison! Here on the one hand were the Viennese, artistic, powerful, daring and broad in their treatment, masterful in their knowledge of multiple-gum technique, sensuous in their strength, yet displaying great taste; on the other, the comparatively tiny Secession prints, full of subtle charm, delicacy, and spirituality, unaggressive in size, color and presentation, yet quite masterful in their technique, and covering a much greater range of media. Watzek, Henneberg, Kuehn and Spitzer, although each a strong individual, were yet so complementary to each other that the whole impression of their collective work was one of uniformity. No doubt this impression was due mainly to the more or less uniformity of size and medium."[44]

Kuehn was already familiar with Stieglitz's work at the time, not just from reproductions but from exhibitions in which they had both participated. He surely saw, and admired, the photograph *Winter, Fifth Avenue* for the first time in 1898 at the Munich Secession. Alfred Stieglitz gave it to him in 1905 as a contribution to a photo collection that was supposed to include not just the works of Austrian colleagues, as it had previously. It is remarkable that Kuehn's experiments around 1902 were largely concerned with the lighting in Stieglitz's work, which was less spectacular in comparison to Kuehn's own work. His few attempts at urban themes survive only as negatives. Either he never printed these shots at all or he destroyed the prints, presumably because, as fascinating as they were, they seemed so foreign to his personal views at the time regarding the goals of art photography.

It is no coincidence that the coming change in the direction of Kuehn's work followed the death of Hans Watzek in 1903 and Hugo Henneberg's subsequent turn away from photography. Left to his own devices, he sought out direct contact to Alfred Stieglitz, because the artistic level of his German and Austrian colleagues did not satisfy him, as he emphasized in the correspondence that rapidly developed between them. In 1904 they met personally for the first time, which "lastingly influenced" Kuehn, as he wrote his new friend in a letter shortly thereafter: "Your visit further accelerated a certain change in my way of thinking."[45]

As mentioned above, Kuehn and Stieglitz photographed together in 1904, and an analysis of the pairs of photographs they made at the time demonstrates what makes this "change" evident. In the first example, the choice of motif was presumably Kuehn's: an atmospheric landscape with a group of trees on a mountain slope, very much in the style of the Trifolium, including leaves moving in the wind (and hence blurry in Stieglitz's platinum print) and cloud formations in the background (see ill. page 14). Apparently neither artist regarded this shot as a great success: Stieglitz exhibited his *Landscape, The Tyrol*,[46] and did not include it in the selection of his most representative photographs.[47] Kuehn did not preserve a print of the surviving negative, even though the photograph would have fit well with his oeuvre of that period.

The outcome of their second outing of their stay in Igls was quite different. They photographed farmers plowing. The results were exhibited repeatedly by Stieglitz as *Ploughing* and *Horses* and published in numerous journals, and the same was true of Kuehn's *Pflüger* (Ploughman), which Stieglitz exhibited as one of the few platinum prints in his Kleeblatt show of 1906.[48] Stieglitz photographed farmers working a number of times, especially during his early stays in the Alps, inspired by Franz Defregger and Eduard von Grützner.[49] Kuehn, too, photographed such scenes occasionally, but always employed the figures as pure staffage, with no allegorical interpretation.

In our case, too, Katherine Hoffmann's interpretation of Stieglitz could scarcely be applied to Kuehn: "*Ploughing,* with its painterly, Pictorial, soft-focus tones, lauds the working farmer, but its layers of gray tones lift the viewer past man and nature into the world of art."[50] The physical effort of turning over the soil and the expanse of the area to be worked are suggested in Stieglitz's photograph: furrows, the edge of the woods, and the crests of the mountains are clearly distinguished; their converging lines and a tiny group of trees in the background suggest a distance to be overcome with effort. In Kuehn's photograph, however, the scene has been broken down completely into flickering light, the individual clods of earth, and the back of the ploughman and almost made to shimmer. The farmer is working almost parallel to the picture plane; his shadow occupies more of less the same space as the animals that have fused into one large form.

These different interpretations of the same theme point to completely distinct basic attitudes of the two photographers. Stieglitz sought visual contexts for a very personal interpretation of the world, as can be read from his description of the making of his famous photograph *The Steerage*: "I saw shapes related to each other. I saw a picture of shapes and underlying that the feeling I had about life."[51] By contrast, Kuehn translated what he saw—"man and nature"—into an almost abstract interplay of planes. Kuehn's interest was in the photograph as a two-dimensional construct; expressing "feelings about life" was secondary for him.

Both photographs are refined studies of tonal values, that is, the controlled gradation of brightness, which had long since been the true heart of photography for both men. For Kuehn, this would become the dominant theme of his subsequent work, carrying far more weight than any depiction of atmosphere. That is why the large-format gum prints suddenly disappeared, beginning with *Pflüger*. As Kuehn wrote Stieglitz, they almost seemed "crude" to him.[52]

Heinrich Kuehn's trip to Katwijk several weeks after they met resembled a kind of repetition of their work together. Both photographers had been to this place previously, which had also attracted numerous contemporary painters, such as Kuehn's idols Fritz von Uhde and Max Liebermann. It was not just the landscape and the light there that has a very particular character: the artful dress of the local women, who were accustomed to posing for artists, in their brilliantly white bonnets contrasting with their dark clothing were particularly fascinating.

There Stieglitz had created a photograph that he would describe in 1899 as his "favorite picture."[53] During an earlier stay in 1901, Kuehn was quite clearly inspired by this frequently published photograph but reinterpreted in a—to employ Stieglitz's words—"daring and broad"

large-format gum print. Here again the pictorial space appears to have been folded out into a plane. Whereas Stieglitz concentrated on the industrious activity of the fisherman's wife, Kuehn focused above all on the expressive contour line and the distinct surface structures of the marram grass and the fabric of her clothing.

On his return in 1904, however, Kuehn produced the print *Frauen in der Düne* (Women in the Dune), which adopted the qualities Stieglitz had admired about the American works shown in Dresden. The latest research shows that Kuehn continued to exhibit his early large gum bichromate prints after 1904 but he produced no more new ones.[54] By contrast, even in the 1940s he was still experimenting with the negatives produced during the decade after 1904. The meeting with Stieglitz did indeed have lasting consequences.

THE INFLUENCE OF THE PHOTO-SECESSION

In spring 1905 the Camera Club organized a group exhibition at the Galerie Miethke with a large selection of American photographs chosen by Stieglitz. They were smaller works, mostly platinum prints. In addition to their more intimate formats and subtler depictions, the scenes with figures were very lively. Heinrich Kuehn was deeply impressed; he both saw his own ideas confirmed and felt inspired to attempt new experiments. He purchased several of the works presented; others would become part of his collection later as a result of exchanges with Gertrude Käsebier, Clarence White, and Edward Steichen. Not coincidentally, Kuehn requested from his new correspondence partners the photographs with the "refined American lighting," as Fritz Matthies-Masuren had characterized it.[55]

Max Liebermann, Study for *The Net-Menders/
Studie zu den Netzflickerinnen*, charcoal drawing on paper, 34.9 x 52.7 cm (13 ¾ x 20 ¾ in.).
Albertina, Vienna

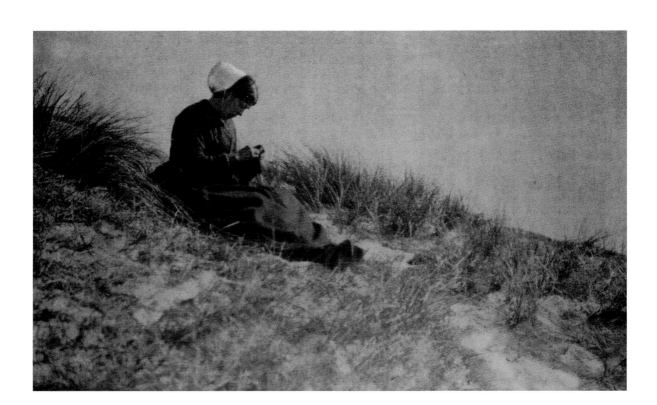

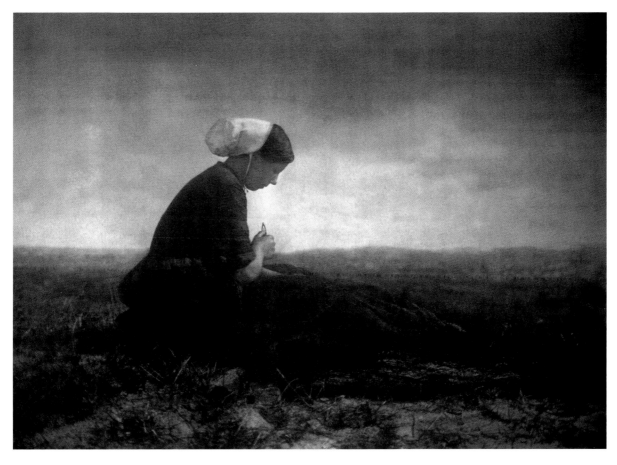

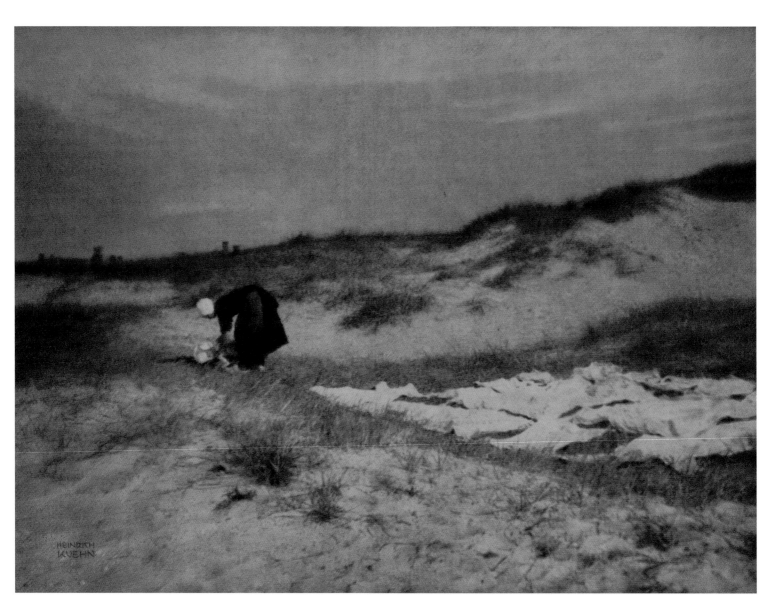

Heinrich Kuehn, *Washerwoman in the Dunes Landscape/Wäscherin in Dünenlandschaft*, 1904, gum bichromate print, 54.6 x 73 cm (21 ½ x 28 ¾ in.).
Courtesy of George Eastman House, International Museum of Photography and Film

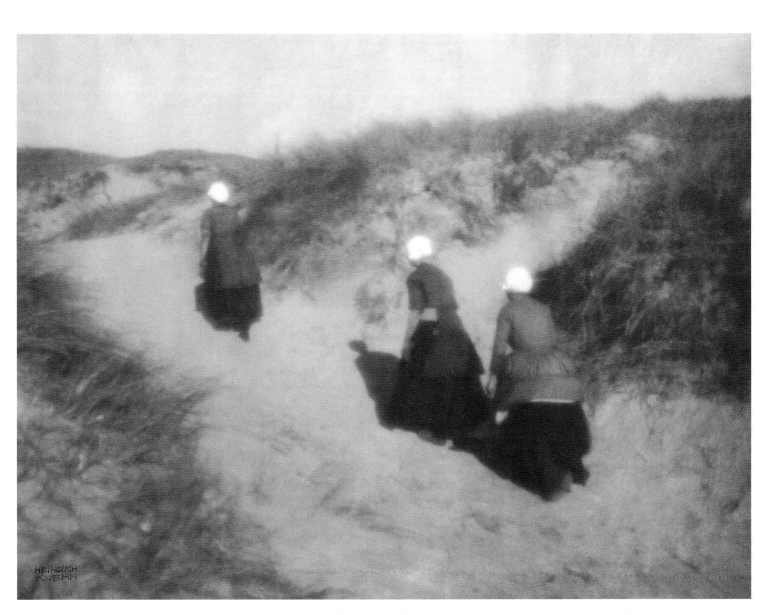

Heinrich Kuehn, *In the Dune*, 1904, gum bichromate print, 31.8 x 40.6 cm (12 ½ x 16 in.). Collection Raymond E. Kassar, Courtesy Cheim & Read, New York

Heinrich Kuehn, *Torbole on Lake Garda/Landschaft bei Torbole*, 1906, multiple oil transfer print, 26.7 x 37.6 cm (10 ½ x 14 ¾ in.). Private Collection. This image was reproduced in a flipped-horizontal format in *Camera Work* no. 33, 1911.

Kuehn's landscapes seemed to be immersed in an entirely new light. Rather than motifs chosen with an eye to an expansive "decorative" effect resulting from the coarse surface of a gum print dominating everything, he now sought smaller, more discriminating details, which he worked out with a much finer structure. It is surely no coincidence that Alfred Stieglitz preferred precisely such works for illustration in *Camera Work*, as they were much closer to his own interests than Kuehn's monumental works had been, although for the reason indicated above he preferred the latter for exhibitions in his gallery.

Kuehn's relationship to the figurative would transform even more drastically; now it dominated his work, but in a different form. For the first time, he recognized the portrait as an artistic challenge and addressed directly the relationship of the figures to the surrounding space or to the landscape, whereas previously they had functioned merely as staffage to enliven the foreground. He developed an effusive enthusiasm for a new type of genre scene that he had encountered in the works by Käsebier and White shown in Vienna. Eugen Kalkschmidt summed up the impres-

Heinrich Kuehn, *Winter Landscape/ Winterlandschaft*, ca. 1905, gum gravure, 20.9 x 28.5 cm (8 ¼ x 11 ¼ in.). Private Collection. This image was reproduced in *Camera Work* no. 33, 1911.

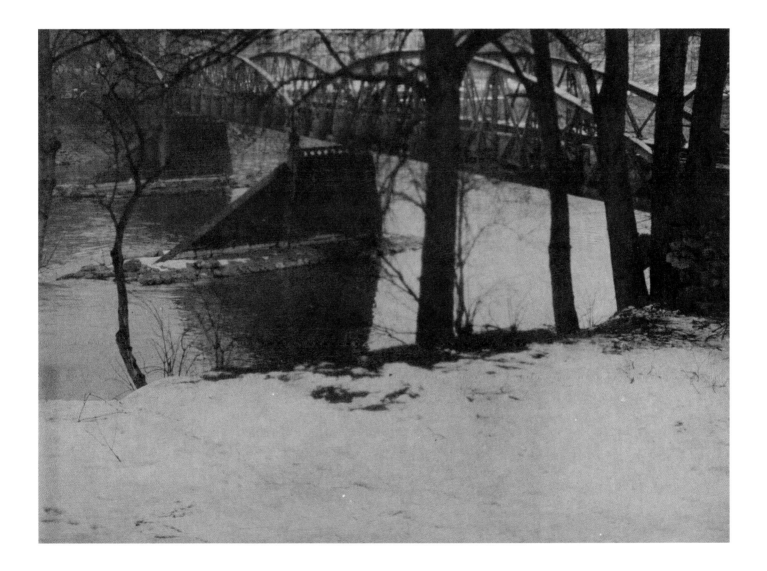

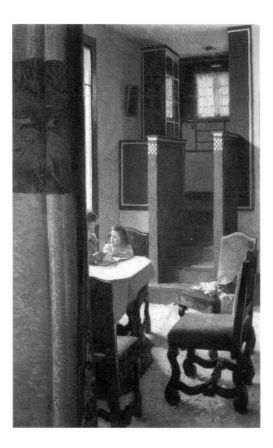

Carl Moll, *Interior*, 1903, oil on canvas,
135 x 89 cm (53 ⅛ x 35 in.). Wien Museum

Clarence White, *Illustration for Eben Holden*,
1903, heliogravure, 19.5 x 15.1 cm (7 ⅝ x 6 in.)
from *Camera Work* no. 3, 1903

sion made on German and Austrian photographers: "The significance of the Americans is based on the portrait, on figurative depictions per se. In this freest of all the spheres of photographic activity, they have found a number of genuinely free motifs whose essence is more or less conditioned by action."[56] This "action" would now play a decisive role in both interiors and landscapes. Kuehn was concerned with questions of subject matter but even more so with formal problems.

Kuehn experimented with a series of light-flooded genre scenes in his newly completed house in Innsbruck, in which the influence of Clarence White quite clearly played an essential role. Kuehn may also have taken his lead for these scenes from the nearly contemporaneous interiors of Carl Moll, who stated a kind of Biedermeyer family idyll—also in the Hofmann house he had only recently occupied. Although Kuehn had photographed members of his family before, the fact that this now became a dominant theme was probably the result not only of new artistic paradigms but also of changes in his living situation.

His contact to the Wiener Camera Club was less close after the death of Hans Watzek. He traveled more rarely to Vienna and more or less ceased entirely the photo excursions he had previously taken regularly. He withdrew to Innsbruck almost completely, and the building of the new house made great demands on his time. Although Kuehn—like Stieglitz—felt his wife did not understand his efforts as an artist, he was profoundly shaken when her latent tuberculosis became manifest in 1904; she died in autumn 1905 after suffering greatly for a year.

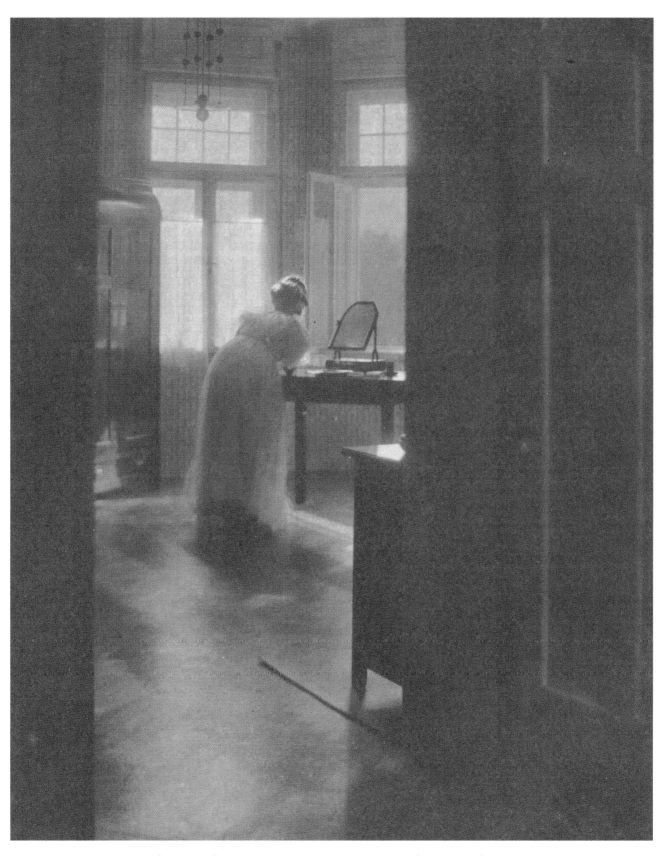

Heinrich Kuehn, *Morning Toilette (Mary Warner)*, 1908, gum bichromate print, 29.9 x 23.8 cm (11 ¾ x 9 ⅜ in.). Private Collection

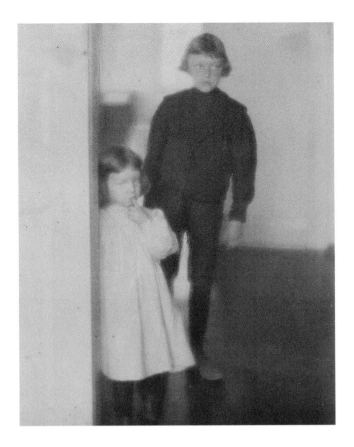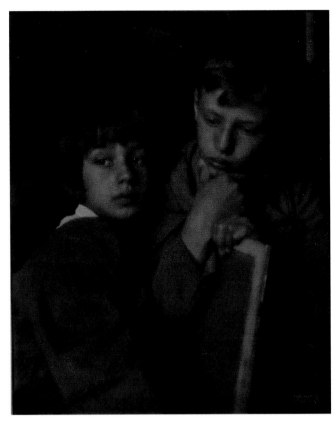

Clarence White, *The Beatty Children*, ca. 1903, carbon print, 23.5 x 17.5 cm (9 ¼ x 6 ⅞ in.). Private Collection. This print comes from the collection of Heinrich Kuehn.

Heinrich Kuehn, *Walther and Hans Kuehn/ Walther und Hans Kuehn*, ca. 1906, gum bichromate print, 29.9 x 23.6 cm (11 ¾ x 9 ⁵⁄₁₆ in.). The Museum of Modern Art, New York. Gift of Joel and Anne Ehrenkranz Fund and Purchase

More than ever his photography focused on his children, who were patient and soon practiced models for him. Photographs of his four children—Walther (b. 1895), Edeltrude (b. 1897), Hans (b. 1900), and Lotte (b. 1904), alone or in various combinations—constitute the most numerous group in Heinrich Kuehn's oeuvre. Among the many famous photographs, however, there are just a few in which his new familial situation is palpable as a deliberate theme. A double portrait with Walther and Hans is one example: appearing in the background between the heads of the two boys is the head of a Madonna, clearly from a quattrocento painting, as a kind of memento of their lost mother. Such allegorical echoes are very rare in Kuehn's work; they entirely lack the allusions—often literary ones—of the titles of the American photographs that influenced him. He seems to have been more concerned with capturing the distinct characteristics of his children as he attentively watched them grow up.

Walther, who always seems melancholy, had artistic ambitions early on, which were encouraged by his father, and hence he was often portrayed accordingly: looking at or painting a canvas. Later there would be a keen mutual influence in the work of father and son: Walther had close contact with the painters in his father's circle of friends and produced prints and drawings of several of the photographs. Heinrich, in turn, was clearly inspired by his son's nudes and took several photographs of nude men at Lake Garda, although all prints of these works are believed to have been lost.

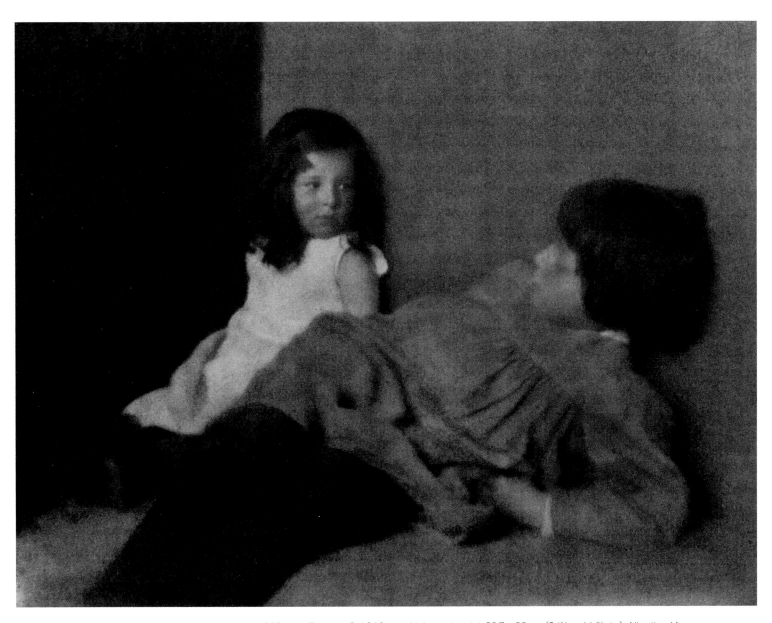

Heinrich Kuehn, *Lotte and Hans Kuehn*, photograph ca. 1908, print February 9, 1910, gum bichromate print, 22.7 x 29 cm (8 $^{15}/_{16}$ x 11 $^{7}/_{16}$ in.). Albertina, Vienna

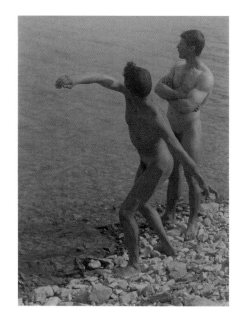

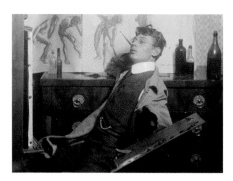

Heinrich Kuehn, *Male Nudes on Lake Garda*, ca. 1906, after original negative

Heinrich Kuehn, *Walther Kuehn*, 1912, after original negative

Heinrich Kuehn, *Walther Kuehn*, ca. 1912, gum bichromate print, 40 x 29.8 cm (15 ¹¹/₁₆ x 11 ¾ in.). Private Collection, New York

In the show at the Galerie Miethke, both Kalkschmidt and Kuehn had been particularly struck by the vividness of the photographs of his American colleagues, without the "momentary" effects of unconventional phases of movement otherwise hidden to the eye that had found their way from scientific photographs into amateur photography in the 1890s. Kuehn printed only the clearest—one could equally say the least ephemeral—of the many surviving negatives, which was surely a consequence of his shyness about randomly captured poses he did not regard as aes-

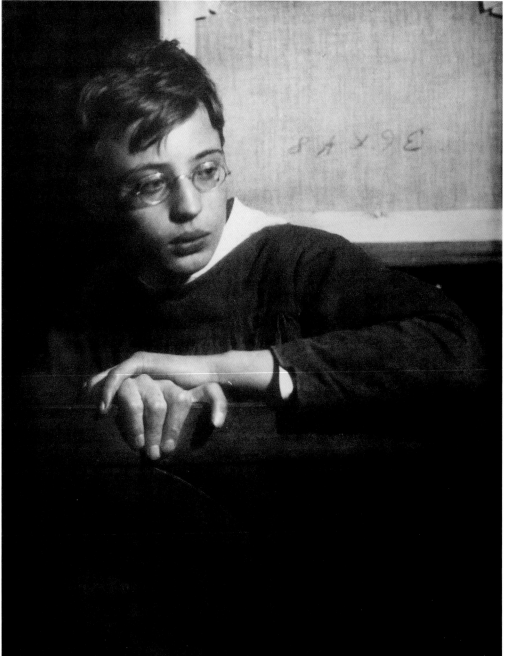

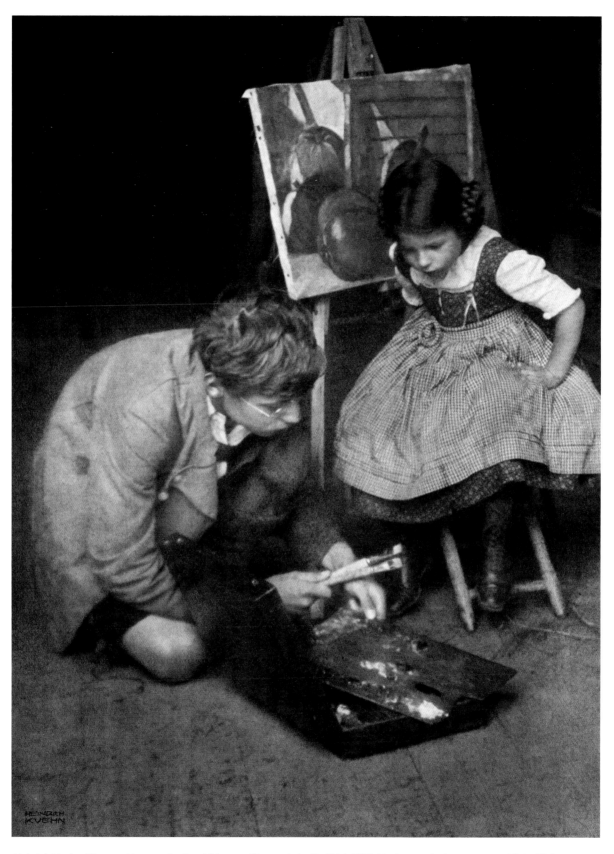

Heinrich Kuehn, *Hans and Lotte at the Easel/Hans und Lotte mit der Staffelei*, 1909, bicolor gum bichromate print, 46.4 x 33.3 cm (18 ¼ x 13 ⅛ in.). Private Collection

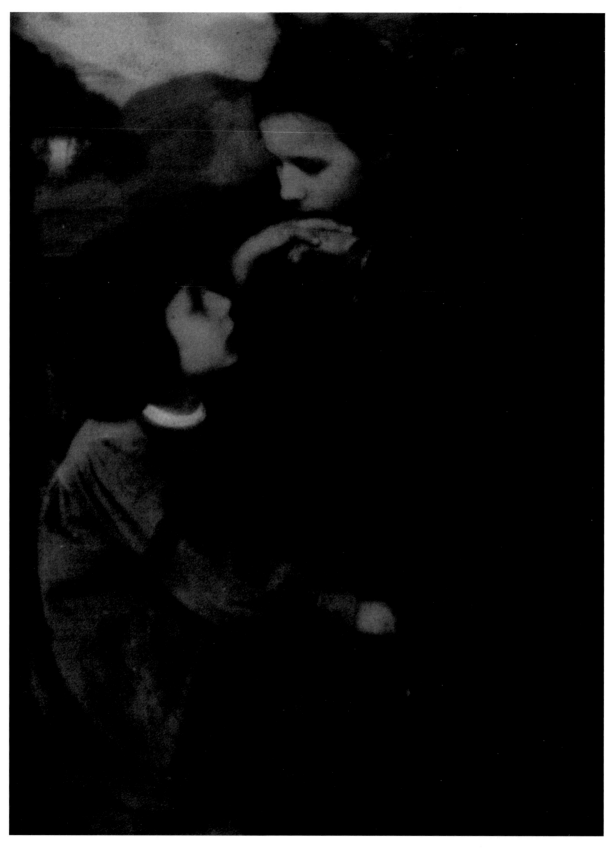

Heinrich Kuehn, *Edeltrude Kuehn and Hans Kuehn in Blue Smocks*, ca. 1908, autochrome, 24 x 17.9 cm (9 ½ x 7 in.). Courtesy of George Eastman House, International Museum of Photography and Film

thetic. Trained in the tradition of painting, he viewed every photograph as an intentional creation; nothing could be left to chance. Hence he often began his work with a sketch. The children were to adopt the corresponding poses and vary them in accordance with their father's wishes. Finally, from the many negatives taken in one "session," he chose one that was then subjected to the complicated processes of copying and their effects, which he also planned in advance.

This approach is diametrically opposed to the "spontaneous" possibilities of photography and their surprising results, which were already admired by many of his contemporaries and after the First World War would become one of the leading approaches as part of the New Vision. This was not in keeping with his own ideas. "We do not see the way quick shots would often lead one to believe. We have merely grown accustomed to taking the photographic document to be correct. Mechanical photography produces results that are usually far from personal experience," wrote Kuehn as late as 1937.[57] The idea described in connection with the early landscapes that the "personally experienced" should be regarded as a purely subjective, "soulful" process, which cannot be achieved by the "soulless" apparatus is one Kuehn would never abandon. The artistic imagination had to crystalize the experience into a pictorial idea that could then be realized. In Kuehn's eyes, it was necessary to have a thoroughgoing artistic adaptation focused on certain pictorial ideas. On principle he rejected the chance, uncontrollable aspect of photographing people in motion, in terms both of the gestures themselves and of the bodies intersecting the edge of the photograph. In the years that followed, Kuehn's work came to be characterized by an overcoming of the contradiction between the spontaneous impression of an image, which was, essentially what was desired—and what fascinated him about Käsebier and White in particular—and this conceptual approach. Yet he avoided fragmentary details, as is clear from a comparison with Käsebier's *Happy Days*, of which he possessed a print.

Like other amateur photographers, Heinrich Kuehn had also photographed character heads in the 1890s, usually peasant faces whose distinct faces appealed to the physiognomic interest of the era. Other than those, he produced only large-format figure studies of his immediate family and his closest friends. Only his encounter with Steichen's portraits in the Galerie Miethke in 1905 and the commissioned portraits of Frank Eugene, who that same year accepted a professorship at the Lehr- und Versuchsanstalt für Photographie in Munich and was visited frequently by Kuehn, changed Kuehn's attitude. He designed two studios for his house in Innsbruck: one with white paneling and one with dark wood, which enabled him to devote himself primarily to portraits with strong contrasts of brightness. When he later began to have financial problems, he produced numerous commissioned works there, which were once again concerned with the problem of translating the "momentary."

Hence even in his portraits Kuehn did not deviate from the approach described above. For everything he photographed, he made "first drawings, and one takes up the camera only when a particularly good pose results. Naturally very detailed study of the great models, namely, of the originals in our galleries, is of great use here as well." This was followed by lighting studies: "From that one learns to recognize how the highly mobile plastic form of a head can be simpli-

Gertrude Käsebier, *Happy Days*, ca. 1902, platinum print, 34.5 x 25.3 cm (13 ⅝ x 10 in.) © Estate of Gertrude Käsebier. This print comes from the collection of Heinrich Kuehn.

Frank Eugene, *Claire*, 1901, platinum print, 17 x 12 cm (6 ¾ x 4 ¾ in.). Private Collection. This print comes from the collection of Heinrich Kuehn.

Heinrich Kuehn, *Herta Bahlsen*, ca. 1911, gum bichromate over platinum print, 29.1 x 21.7 cm (11 ⁷⁄₁₆ x 8 ⁹⁄₁₆ in.). Private Collection

fied in self-contained, sharply characterized areas of light and shadow. [...] One studies the masterly use of the cast shadows of sunlight by the likes of David Octavius Hill." He called the results of this work "notes with the camera."[58] Only after the models had visited his studio several times did he progress to the photography proper, which was an extremely tense experience for him: "The painter can combine various impressions in one portrait. The photographer—under the most extreme nervous tension imaginable—has to see everything he needs for the image without exception unified in one moment. And that moment again—this is the frightfully difficult aspect of the portrait—has to exclude everything momentary, the temporarily rigid." Kuehn considered lighting effects and the moment to be the essential points in the "genetic difference" between photography and the "freely creative graphic arts," which could not be directly compared: "Photography has as essential qualities that it can very faithfully and exhaustively record momentary atmospheres, that the image results from a uniform mold, not from a series of temporally sequential impressions, that it works with tonal values alone, without contours, and that it is capable of rendering the most delicate subtleties of the play of light with almost unsurpassable elegance and convincing truth."[59]

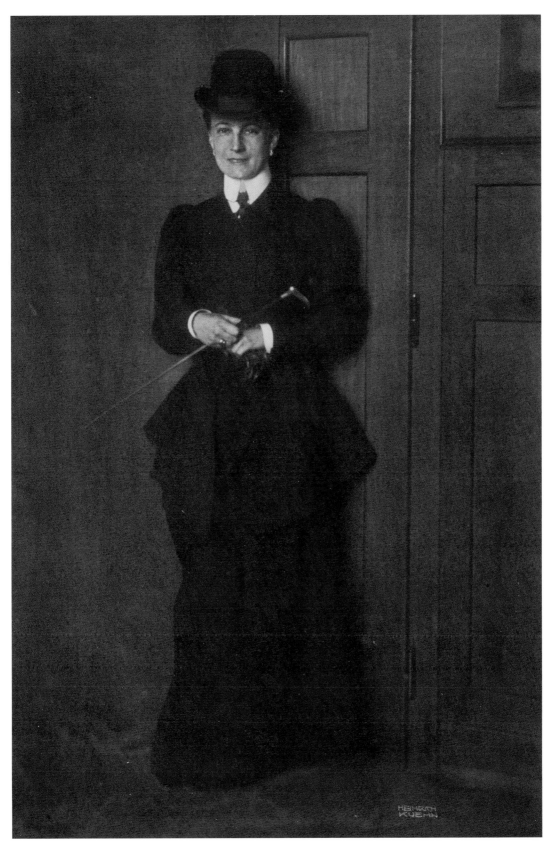

Heinrich Kuehn, *Rider, Standing*, ca. 1909, gum bichromate over platinum print, 38.9 x 25.9 cm (15 ⁵/₁₆ x 10 ³/₁₆ in.).
Private Collection

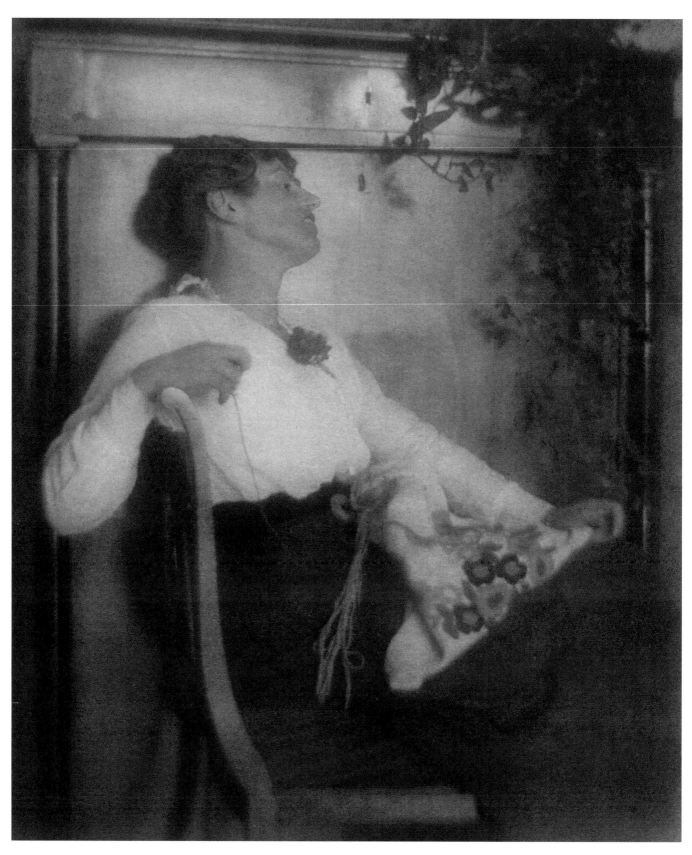

Heinrich Kuehn, *Mrs. Richter/Frau Richter*, ca. 1913, multiple oil transfer print on Japanese paper, 29.7 x 24.7 cm (11 ¹¹⁄₁₆ x 9 ¾ in.).
Photoinstitut Bonartes, Vienna

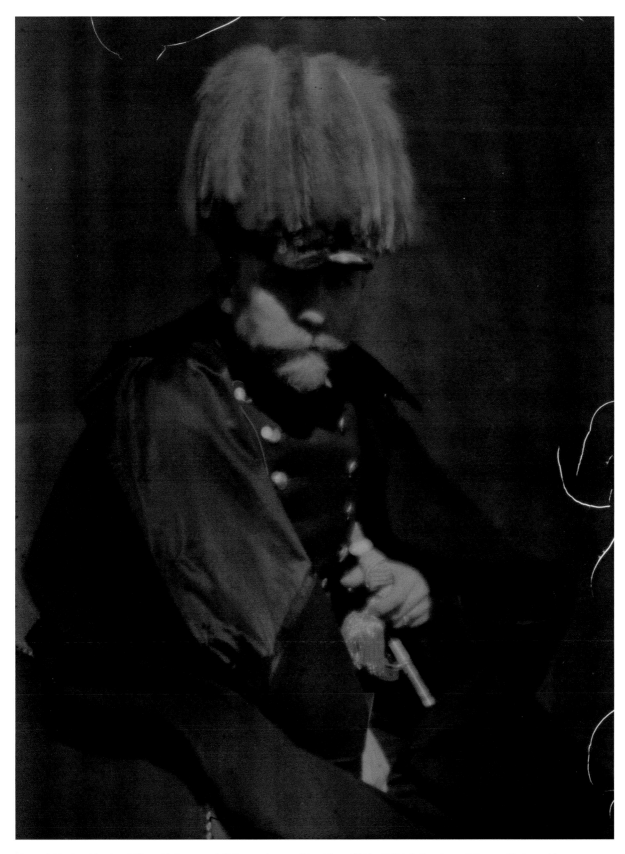

Heinrich Kuehn, *Man in a Military Uniform*, ca. 1908, autochrome, 24 x 18 cm (9 ½ x 7 ⅛ in.). Courtesy of George Eastman House, International Museum of Photography and Film

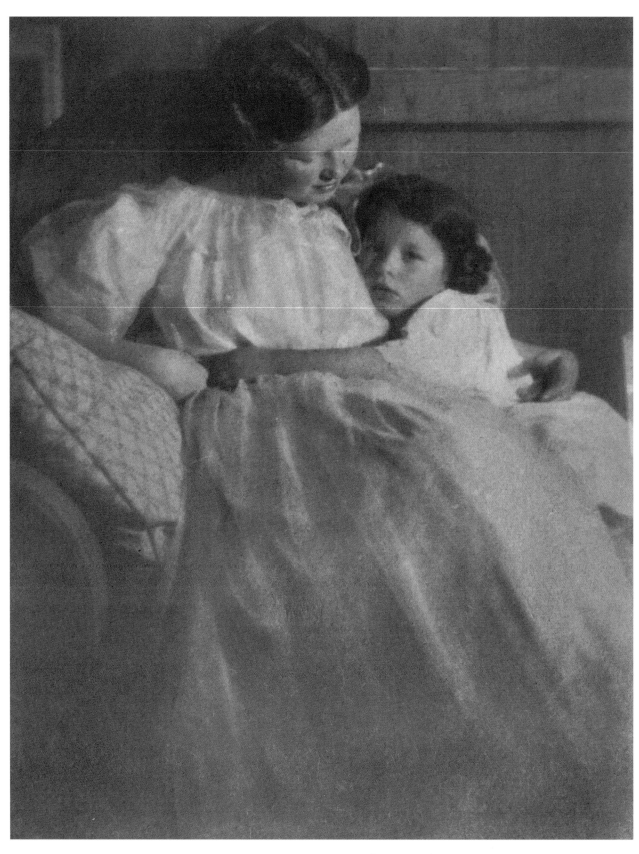

Heinrich Kuehn, *Miss Mary and Lotte*, 1908, multiple oil transfer print, 22.4 x 17 cm (8 ⅞ x 6 ¾ in.). Lee Gallery

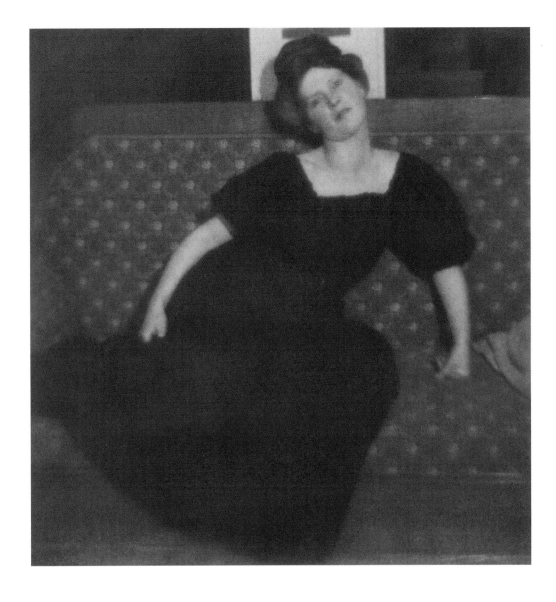

Heinrich Kuehn, *Miss Mary Warner on the Sofa II*, 1908, gum bichromate over platinum print, 23.2 x 22.1 cm (9 ⅛ x 8 ¹¹⁄₁₆ in.). Private Collection

STUDIES OF TONAL VALUES

In this critical phase of his life, Kuehn met an extraordinarily patient and understanding model for his incessant efforts to approach his ideals of art photography: following the birth of his youngest child, Lotte, and the illness of his wife, the young Englishwoman Mary Warner came to work for the family as a nanny. After Emma Kuehn died she not only took up the role of mother to the children but also took charge of the entire household. There is no written documentation of how the relationship between this young woman and the man of the house evolved, but if one accepts the family tradition there is no doubt that the two of them had a love affair that lasted until Mary Warner's death in 1933.

The photographs suggest such an interpretation as well. Not only were there countless portrait studies and scenes in which Mary's motherly relationship to the children is sympathetically depicted, but also, beginning in 1907, nudes that simply radiate sensuality. An essential role in

Edward Steichen, *La Cigale*, 1901, waxed platinum and gum print, 27.3 x 31.1 cm (10 ¾ x 21 ¼ in.). Collection Raymond E. Kassar, Courtesy Cheim & Read, New York. Permission of the Estate of Edward Steichen.

Edward Steichen, *The Little Round Mirror*, 1902, waxed platinum and gum print, 49.5 x 33 cm (19 ½ x 13 in.). Collection Raymond E. Kassar, Courtesy Cheim & Read, New York. Permission of the Estate of Edward Steichen.

Copies of these two prints were in the collection of Heinrich Kuehn.

the latter is played by Mary's unusually long hair, which Kuehn dramatized in a great variety of ways. With his detailed knowledge of Viennese painting in his day, it must have been a welcome coincidence for Kuehn that she had gleaming red hair, as Gustav Klimt also regarded red hair as a symbol of female sensuality. Another sign of his heightened awareness of the body is a series of male nudes from the same period that are probably self-portraits.

The influence of American photographers also played an essential role in Kuehn's interest in the subject of the nude, as is clear from a comparison of the photographs by Edward Steichen he collected, which are closely related to his own in terms of pose and expression. Kuehn's rendering of the surfaces of materials, especially of human skin, was, however, new: with the classic gum print, it had not been possible to evoke their delicacy and shimmer. "The photographs of the Photo-Secession showed me that these magnificent subtleties of tone could be produced photographically,"[60] as Kuehn wrote Stieglitz in 1905.

The control of "tonal values" and subtleties of tone as a central concern of art photographers was nothing new. Following Emerson, Stieglitz stated as early as 1892: "What atmosphere is to Nature, tone is to a picture,"[61] and in *Camera Notes* there are numerous texts on the subject. Kuehn's credo was: "If the value (the quality that cannot be replaced by any other medium) of photography lies in the reproduction of tonal subtleties, the usual contact print is wrong. For although it reproduces the middle tones approximately correctly, lights and shadows are totally wrong in terms of their gradations. Ordinary photography can only pick out one tonal group, an octave. For myself, I consider the methods that are at pains to reproduce the tonal values of lights and shadows as faithfully as possible, without painting or somehow retouching, are the superior ones. I am of the opinion that they alone should be spoken of as pure photography."[62]

Here it becomes clear that Kuehn worked to develop a kind of photographic "palette of tonal values," by means of which individual nuances should be as freely available as they are when applying paint. Kuehn developed various methods for doing so and described them in numerous texts. As an ideal illustration of these efforts, he produced, under the forthright title *Tonwertstudien* (Studies in Tonal Values), portraits of Mary Warner in a Biedermeier dress in which the depiction of various surface effects, of gentle sheen and deep shadow, of delicate organza and coarse felt, reached a culmination. The fact that he gave perhaps the most "sensuous" of his studies of Mary a title that refers to the purely formal qualities of the photograph speaks clearly about Kuehn's priorities, which focused on technical aspects of the medium.

Kuehn's point of departure was the knowledge that nature is perceived by colors, which in photography are represented by gradations of monochrome tones—usually of black and white. Kuehn had already encountered this problem in the scientific use of photography; as a medical student he had made microscopic studies. It is not known whether while at the university in Berlin he attended lectures of the physicist Hermann Wilhelm Vogel, as Alfred Stieglitz did, but he was certainly familiar with Vogel's experiments demonstrating that the reproduction of values of light and dark is dependent on the chemical composition of the photographic material and hence has no constant relationship to perception by the human eye.[63]

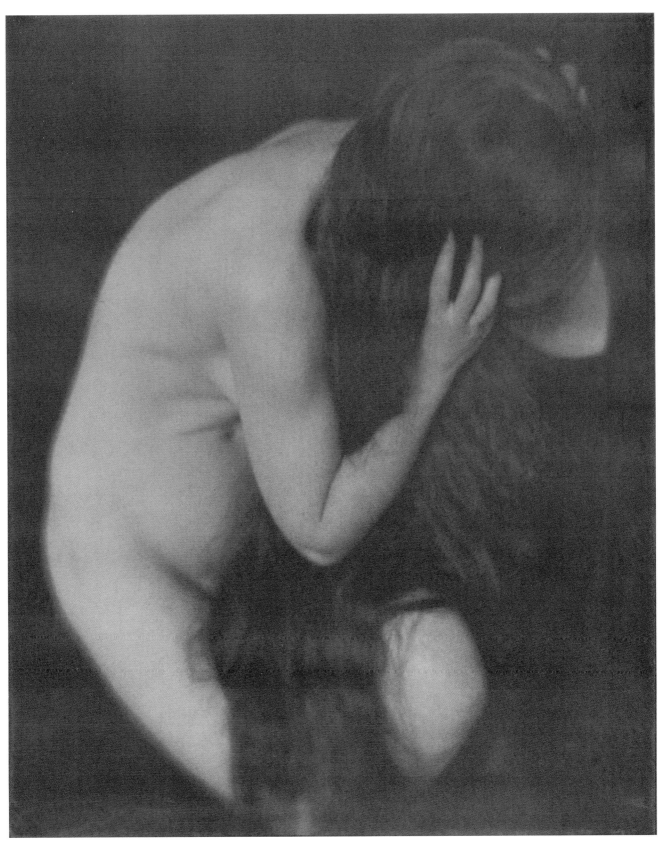

Heinrich Kuehn, *Nude (Mary Warner)/Akt (Mary Warner)*, ca. 1907, platinum print, 29.7 x 23.7 cm (11 ¾ x 9 ⅜ in.). Collection Alexander Spuller, Courtesy Galerie Johannes Faber

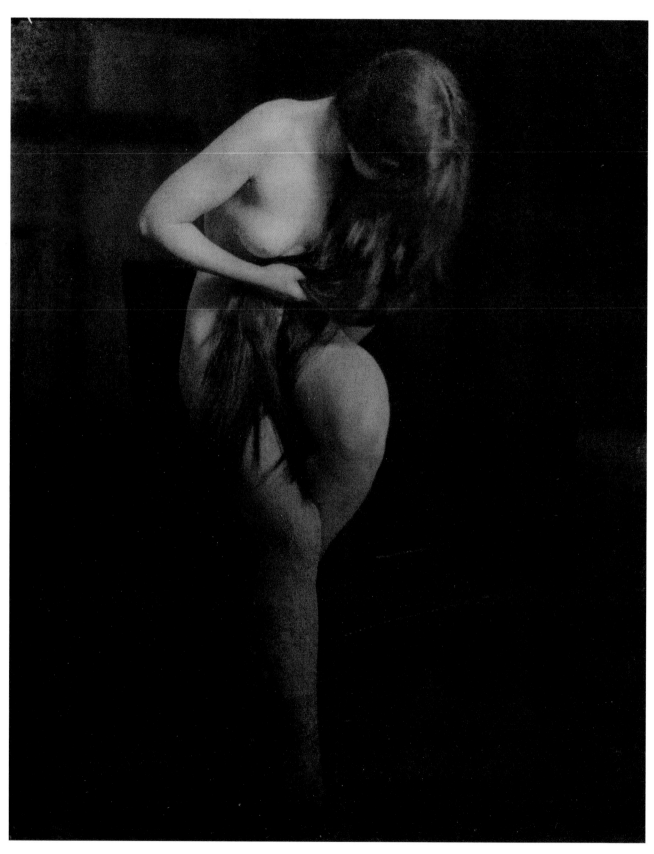

Heinrich Kuehn, *Nude (Mary Warner)/Akt (Mary Warner)*, 1906, platinum print, 29.9 x 23.7 cm (11 ¾ x 9 ⅜ in.). Private Collection

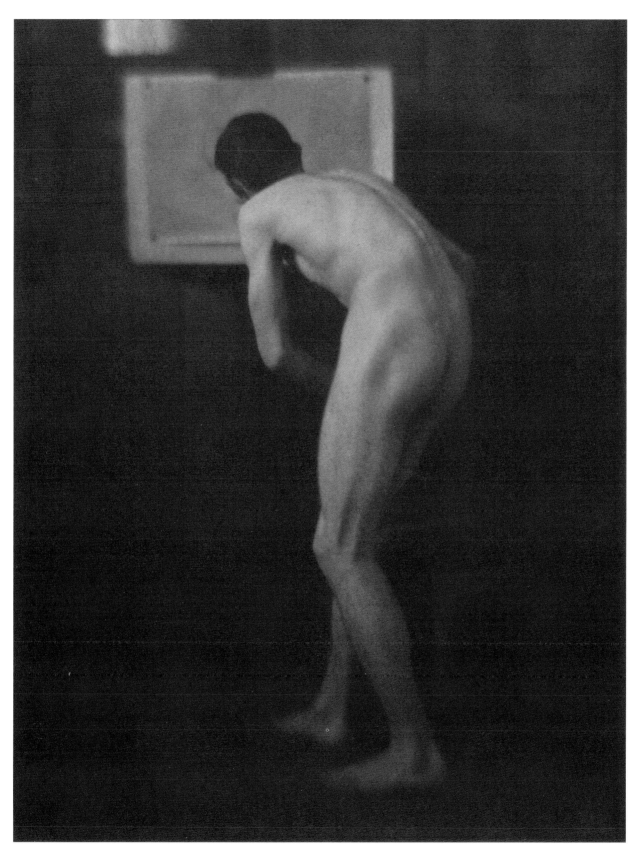

Heinrich Kuehn, *Male Nude*, ca. 1908, gum bichromate print, 38.6 x 29.2 cm (15 ⅛ x 11 ³⁄₁₆ in.). Private Collection

Heinrich Kuehn, *Study in Tonal Values II (Mary Warner)/Tonwertstudie II (Mary Warner)*, 1908, gum gravure, 29.3 x 23.4 cm (11 ⁹/₁₆ x 9 ³/₁₆ in.). Collection Alexander Spuller, Courtesy Galerie Johannes Faber

Heinrich Kuehn, *Study in Tonal Values III (Mary Warner)/Tonwertstudie III (Mary Warner)*, 1908, bromoil transfer print on tissue, 29.2 x 23.2 cm (11 ½ x 9 ¹/₁₆ in.). Private Collection, New York

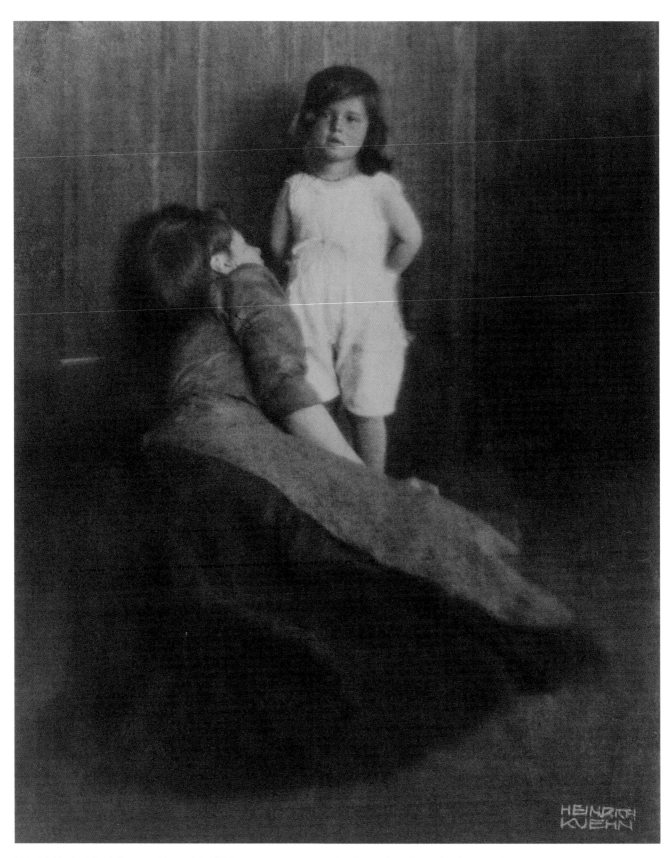

Heinrich Kuehn, *Mary Warner and Lotte*, July 1907, gum bichromate print, 30 x 24 cm (11 13/16 x 9 7/16 in.). Private Collection

That is why Kuehn used a pocket spectroscope and tables showing the equivalent of colors in black-and-white values for each chemical composition of photographic materials in order to plan the effects of his images in advance.[64] In addition, in the years that followed he experimented with combining different printing techniques that made it possible to create incomparably different positives from one and the same negative. He was concerned, on the one hand, with the wealth of nuances, but also, on the other hand, with not being tied to the tones set in the negative. Years later, oil printing and transfer printing would turn out to be the freest options, in Kuehn's eyes.[65] Depending on the quality of the paper, the type and color of the pigment, the temperature, and the concentration of the chemicals used during processes, the surfaces would be more open or more closed, there would be glossy effects or matte structures, areas of saturated color or effects of transparency, and much more.

His "study of tonal values" with the Biedermeier dress is, by the way, part of a considerable "photo wardrobe" Heinrich Kuehn created for Mary Warner—and one for each of the children as well. These clothes were not worn on a daily basis but only for Kuehn's photographs. Their colors and surfaces were chosen with that in mind: white, black, and gray smocks, trousers, dresses, and hats in rough, delicate, or glossy materials. Looking at a series of Kuehn's photographs from 1907 to 1911 side by side, one quickly recognizes the rigor with which he pursued the "intentional creation" of his photographs. Not even the tiniest detail was left to chance: Kuehn carefully selected the site for the photograph—it was in keeping with his need for control that there were just a few places where he photographed again and again. Then the composition was sketched in pencil. Mary Warner and the children then acted and posed precisely according to the photographer's instructions: even at an advanced age, Lotte Kuehn-Schönitzer still recalled that it was not just the choice of clothing (based on the desired color and not the conditions of the season) that placed high demands on the children. Once they had arrived at the site, they had to wait until every cast shadow corresponded exactly to their father's intentions.

Heinrich Kuehn, *Mary Warner and Hans Kuehn*, photograph 1907, print after 1911, gum gravure, 16.7 x 22.2 cm (6 ⁹/₁₆ x 8 ¾ in.). Albertina, Vienna

Heinrich Kuehn, *Meadow in Birgitz (Hans and Mary Seated)*, ca. 1908, oil transfer print on Japanese paper, 19.5 x 27.5 cm (7 ¹¹/₁₆ x 10 ¹³/₁₆ in.). Photoinstitut Bonartes, Vienna

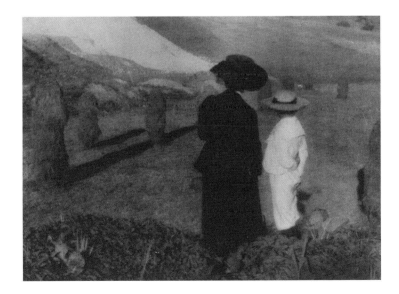

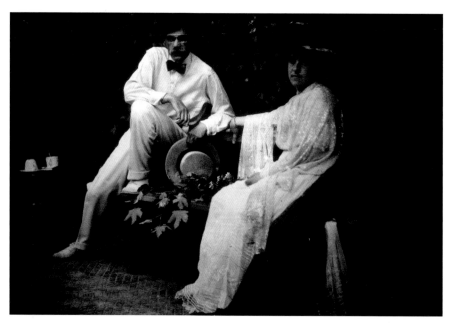

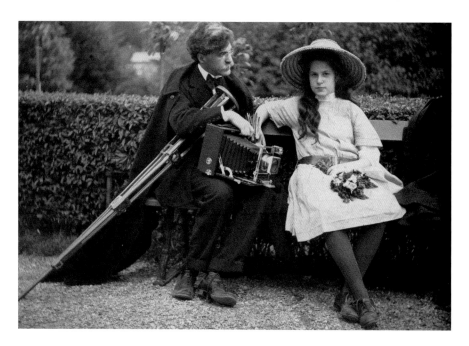

COLOR-MAD

The children's patience would soon be put to the test even more, because Kuehn turned to a photographic technique that required even longer exposure times but permitted less processing *after* the shot than anything he had used before: in summer 1907 Frank Eugene invited him, along with Alfred Stieglitz and Edward Steichen, to meet in the small Bavarian town of Tutzing to experiment with their latest photographic passion, namely, French Autochrome Lumière plates, which had just come onto the market: a process for creating color photographs on a glass background. A series of group portraits testifies to the enthusiastic, almost exuberant atmosphere among these friends during their days in Tutzing.

Especially for Kuehn, with his obsessive pursuit to transfer "natural colors" to a limited palette of tone values, the autochrome represented an unsuspected technical opportunity. For at least two years he was "autochrome-sick."[66] Steichen had already created color photographs using gum prints and was correspondingly enthusiastic; even Stieglitz joined the choir: "The possibilities of the process seem to be unlimited [...] the wonderful luminosity of the shadows, that bugbear of the photographer in monochrome; the endless range of grays; the richness of the deep colors. In short, soon the world will be color-mad."[67] With his usual emphasis, he even ventured a bold prediction: "what the Daguerreotype has been to modern monochrome photography, the Autochromo-type will be to the future of color photography."[68]

At least twenty photographs from Tutzing survive today,[69] and they show that the results did not fulfill all the great expectations for a rich palette of colors. Commentaries by Stieglitz and Kuehn suggest that unexpectedly high demand resulted in deterioration of the quality of the plates delivered by Lumière.[70] On the other hand, Steichen and Kuehn in particular experimented

Opposite:
Emmeline Stieglitz, 1907, autochrome, 12 x 16.6 cm (4 ¾ x 6 ½ in.). Alfred Stieglitz Collection, 1952.308, The Art Institute of Chicago

Stieglitz and Emmy, 1907, autochrome, 11.3 x 16 cm (4 ⁷⁄₁₆ x 6 ⁵⁄₁₆ in.). The Metropolitan Museum of Art, New York, Alfred Stieglitz Collection, 1955 (55.635.12)

Alfred and Kitty Stieglitz, 1907, autochrome, 11.3 x 16.5 cm (4 ⁷⁄₁₆ x 6 ½ in.). Image courtesy of the National Gallery of Art, Washington, D.C. (1949.3.290). © Georgia O'Keeffe Museum/ Artists Rights Society (ARS), New York

Below:
Alfred Stieglitz, autochrome, 18 x 13 cm (7 ¹⁄₁₆ x 5 ⅛ in.). The Metropolitan Museum of Art, New York, Alfred Stieglitz Collection, 1955 (55.635.18)

Two Men Playing Chess, 1907, autochrome, 9 x 12 cm (3 ½ x 4 ¾ in.). The Metropolitan Museum of Art, New York, Gilman Collection, Purchase, Mr. and Mrs. Henry R. Kravis Gift, 2005 (2005.100.476)

The photographs on these two pages cannot be definitively attributed, but are thought to have been made by Frank Eugene, Heinrich Kuehn, and Alfred Stieglitz in Tutzing.

Heinrich Kuehn, *Color Control Patch*, ca. 1907, autochrome. Österreichische Nationalbibliothek, Bildarchiv, Vienna

Heinrich Kuehn, *Miss Mary Warner and Edeltrude Lying on Grass*, ca. 1908, autochrome, 17.9 x 24.2 cm (7 ⅛ x 9 ½ in.). The Metropolitan Museum of Art, New York, Gilman Collection, Purchase, Mrs. Walter Annenberg and The Annenberg Foundation Gift, 2005 (2005.100.739). © Estate of Heinrich Kuehn/Courtesy Galerie Kicken Berlin

individually (and presumably together in Tutzing) with improving the procedures suggested by the manufacturers, though it was inevitable that the results had less radiant colors: "The beautiful tone that the plates had when processing began disappears, unfortunately, during the second development; it becomes considerably colder. Despite all my efforts, I have not managed to preserve these brilliantly warm tones," Kuehn was forced to admit in his first description of the new technique in autumn 1907.[71] This problem would only be overcome a few weeks later. Hence it is not surprising that it is all but impossible to attribute the individual photographs from Tutzing to a particular photographer, as Sarah Greenough has noted.[72]

In 1909 Eugene, Kuehn, Steichen, and Stieglitz met again in Munich, and apparently they again collaborated on autochromes.[73] Yet Kuehn alone worked with this new method for another ten years, at times with great intensity. Using his tables and standard plates, now revised for color processing to show how the autochrome rendered certain hues, Kuehn expanded his field for experiment: the children and Mary Warner were given "photo clothes" in green, blue, and red that were adapted to the "pure color tones" of the three layers of the autochrome plate.

To test the potential of the color process, a new subject came to the fore, one to which Kuehn had not previously paid much attention: the still-life. It had the incomparable advantage that "the still-life can be repeated unchanged more easily, after weeks or a year and a day," as Kuehn announced in his didactic instructions, and, if necessary, all the mistakes could be eliminated on the second or third attempt.[74] This did not just have pragmatic advantages but also brought photography another small step closer to the traditional arts, in which many studies also preceded a

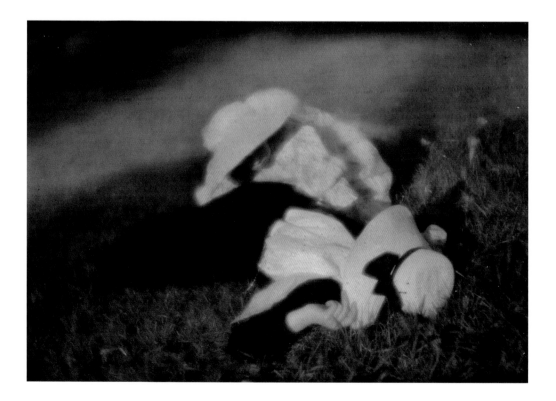

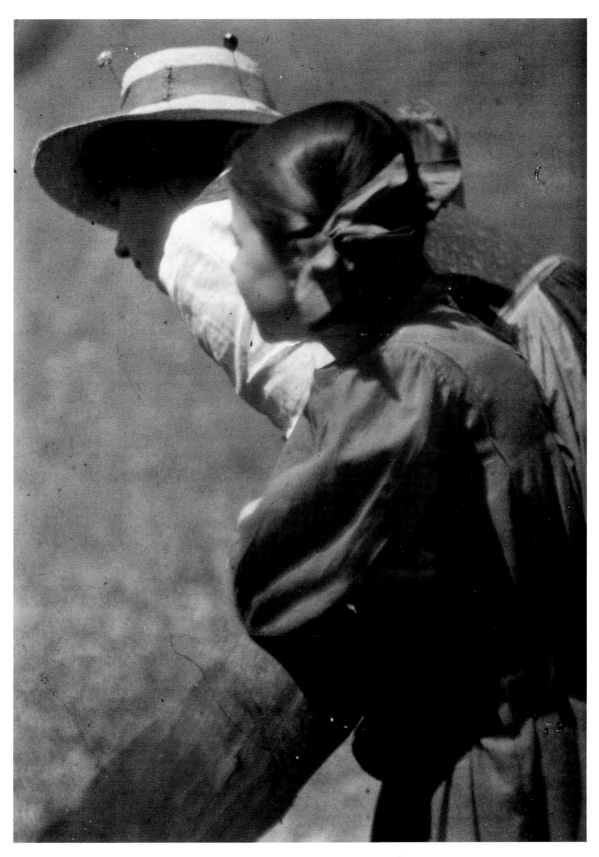

Heinrich Kuehn, *Edeltrude and Lotte*, 1912–13, autochrome, 18 x 13 cm (7 ⅛ x 5 ⅛ in.). Österreichische Nationalbibliothek, Bildarchiv, Vienna

Heinrich Kuehn, *Miss Mary Warner and
Edeltrude Kuehn on a Hillside*, ca. 1910,
autochrome, 18 x 24 cm (7 ⅛ x 9 ½ in.).
Courtesy of George Eastman House,
International Museum of Photography
and Film

Heinrich Kuehn, *The Descent (Walther,
Hans, and Edeltrude Kuehn)/Der Abstieg
(Walther, Hans, und Edeltrude Kuehn)*,
ca. 1908, autochrome, 18 x 24 cm
(7 ⅛ x 9 ½ in.). Courtesy of George
Eastman House, International Museum of
Photography and Film

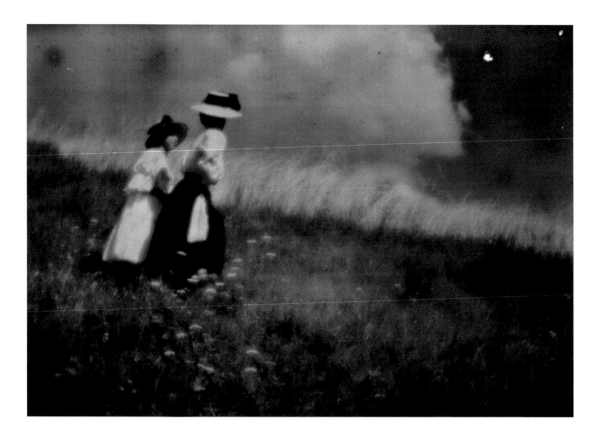

Heinrich Kuehn, *Farmhouse, Rietz/Tyrol*, ca. 1908, autochrome, 24 x 18 cm (7 ⅛ x 9 ½ in.). Courtesy of George Eastman House, International Museum of Photography and Film

Heinrich Kuehn, *Water Glass/Wasserglass*, ca. 1911, print after 1914, multiple oil transfer print on watercolor paper, 23.2 x 17.4 cm (9 ⅛ x 6 ⅞ in.). Albertina, Vienna

successful work. But here it was even easier to regroup the objects in endless experiments, and here there was great freedom in the arrangements: "The task is merely to attempt a pictorial layout with the simplest means possible, without any complicated structure of 'arrangement,' simply with a few objects we happen to have at hand. Whether we chose the glass standing before us on the table as the center of the image, a simple glass of water with its wonderful reflections, relating only to a second or probably also a third body, a lemon, say, and perhaps a small plate; it does not matter at all whether we construct the still life from a tea service or from flowers or books and a box of matches. As long as pictorialism is achieved!"[75] Indeed in his photographs of glasses of water around 1910 Kuehn concentrated entirely on the "wonderful reflections," achieving results that were pure photography yet pushed the distance between object and image to its limits. They depicted rather "the most delicate subtleties of the play of light"[76] as a kind of dissolved, shadowy drawing that could be grasped as nearly abstract. Little more than a suggestion of the reflective glass remained; the background seemed monochrome and completely unstructured.

Over the next ten or twelve years of tirelessly photographing, a slow transformation took place. The broad sections of juxtaposed tone values of different shading—that is to say, the close-up scenes—gave way to larger details in which the figures seem distant and hence small, tiny spots, whose distribution and orientation nevertheless essentially determine the sense of space of the landscape. Now Kuehn began to use sharp perspectives from above or below, which lend these landscapes a hint of the New Vision that would only emerge a decade later. But they lacked the urban connotation that would become characteristic of the unusual perspectives after the First World War; instead Tyrol's mountainous landscape, with its often dramatic prospects, was the inspiration here. Yet the basic experimental attitude of plumbing the depths of the camera's potential as far as possible, and accepting pictorial solutions that are difficult to read as a consequence, is already hinted at here. But Kuehn could not relinquish control. He did

Heinrich Kuehn, *Wine Bottle, Water Glass, and Apple*, photograph ca. 1911, print ca. 1918, gum gravure, 22.9 x 30.7 cm (9 x 12 ⅛ in.). Photoinstitut Bonartes, Vienna

Heinrich Kuehn, *Apples*, ca. 1912, autochrome, 18 x 24 cm (7 ⅛ x 9 ½ in.). Photoinstitut Bonartes, Vienna

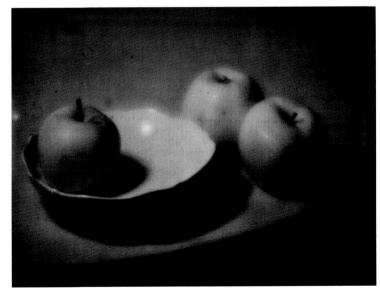

Heinrich Kuehn, *Hikers on the Edge of the Shadows/Wanderer an der Schattengrenze*, ca. 1915, multiple oil transfer print, 21.2 x 29.4 cm (8 ¼ x 11 ⁹⁄₁₆ in.). Photoinstitut Bonartes, Vienna

Heinrich Kuehn, *Hikers on the Edge of the Shadows/Wanderer an der Schattengrenze*, ca. 1915, multiple oil transfer print, 21.2 x 29.5 cm (8 ¼ x 11 ⁵⁄₈ in.). Photoinstitut Bonartes, Vienna

In the photograph at the top of this page, Kuehn removed his son Walther from this version of the print.

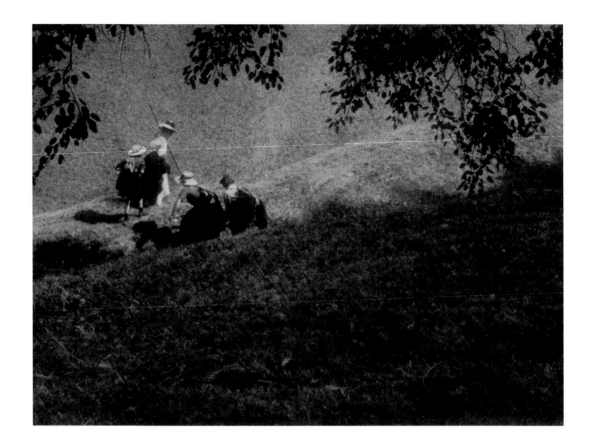

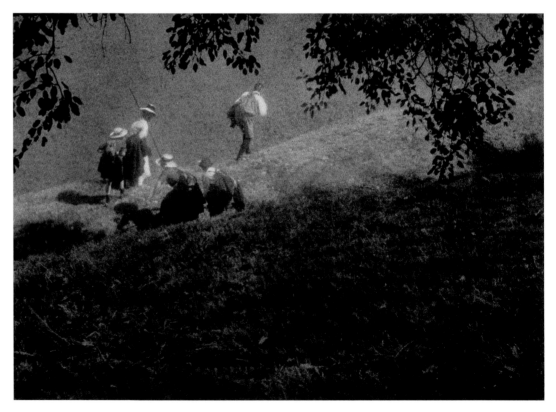

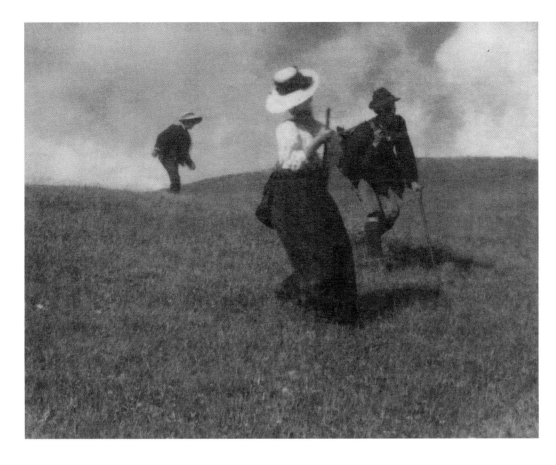

Heinrich Kuehn, *Descent/Abstieg*, ca. 1912, platinum print on Japanese paper, 16.2 x 20.1 cm (6 ⅜ x 7 ⅞ in.). Private Collection

Heinrich Kuehn, *Hikers in Front of a Cloud*, 1912–13, gum bichromate over platinum print on Japanese paper, 20.5 x 28.3 cm (8 ⅟₁₆ x 11 ⅛ in.). Private Collection

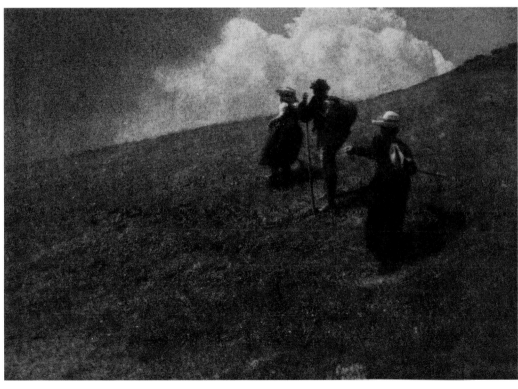

not shy away from leaving one child or another out of the picture if it was necessary to achieve his ideas of harmony in the pictorial field: as a perfect retoucher—albeit one who vehemently denounced the activity—Kuehn did not have to worry about whether what he had eliminated would leave traces behind. Nor was it a problem for him to turn a view downward into a view upward by replacing a bit of meadow with a cloud-filled sky.

THE CONSEQUENCE OF AESTHETIC ESCAPISM

Balancing random events, harmonizing and manipulating external reality in photography around 1900 was intended not just to imitate the gesture of painting but was also about a rejection, common to all art movements at the time, of "dead appearances" that spoil the "spiritually free moment." Reflection on appropriate means of expression led to a radical turn, which led Hugo von Hofmannsthal, among others, to realize that "perhaps we have to relearn and learn back, and above all learn to be silent about everything we observe."[77] Leaving out, being silent and turning from reality led to an experimental sounding out of the artistic possibilities specific to a medium and hence to a discussion of the creative potential that leads to a more or less abstract production of art of the sort Kuehn attempted with his glass of water.

The conscious rejection of photographic details and the nearly total break from nature as a model is, on the other hand, also an expression of the attempt to flee a world perceived as discordant and to negate changing social conditions. On this point, photographers were also in agreement with contemporary artists: "Painting reflects on its very own means of expression and dreams of a world that is self-contained, rests deep inside human beings, awaiting its resurrection. It would like to conjure up a small paradise, as all eras of art have conjured one up," read

Clarence White, *The Orchard*, 1902, platinum print, 24 x 19 cm (9 ½ x 7 ½ in.). Private Collection. This print comes from the collection of Heinrich Kuehn.

Heinrich Kuehn, *Summertime*, ca. 1917, multiple oil transfer print, 38.5 x 27.4 cm (15 ⅛ x 10 ¾ in.). Private Collection

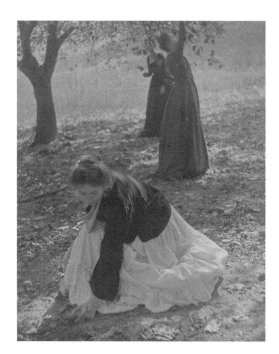

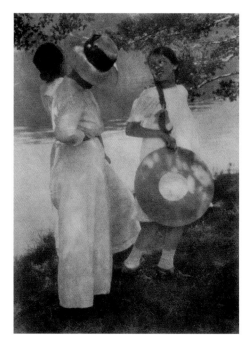

Heinrich Kuehn, *Study in Tonal Values (Edeltrude on the Hillside)/Tonwertstudie (Edeltrude am Hang)*, ca. 1907, multiple oil transfer print, 23.5 x 29.5 cm (9 ¼ x 11 ⅝ in.). Dietmar Siegert Collection, Germany

Heinrich Kuehn, *The Garden of the Kuehn Villa in Summer/Blick auf den Garten der Kuehn Villa im Herbst*, 1908, autochrome, 13 x 18 cm (5 ⅛ x 7 ⅛ in.). Österreichische Nationalbibliothek, Bildarchiv, Vienna

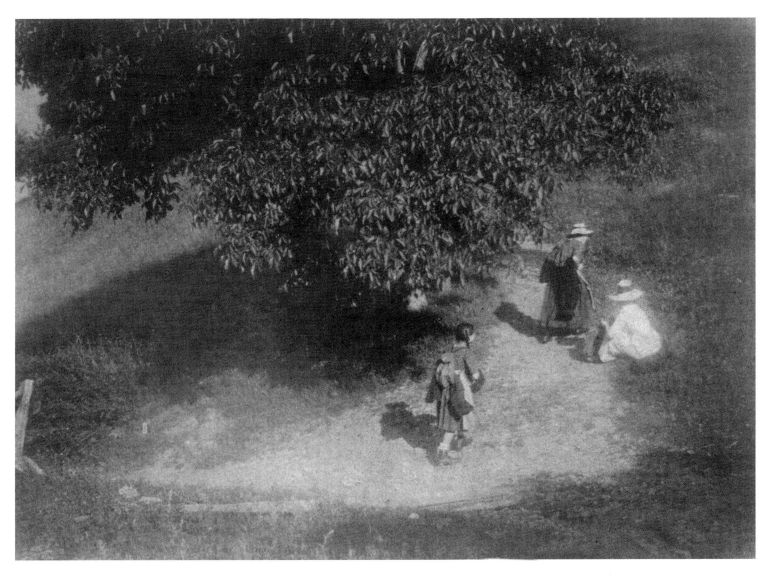

Heinrich Kuehn, *Hikers beneath a Tree/Wanderer unter einem Baum*, ca. 1914, multiple oil transfer print, 21.4 x 29.7 cm (8 ⁷⁄₁₆ x 11 ¹¹⁄₁₆ in.).
Collection Christian Brandstätter, Vienna

Oskar Kokoschka, *The Awakening/Die Erwachenden*, color lithograph, from *The Dreaming Youths/Die Träumenden Knaben*, Vienna 1907, printed 1908. © 2012 Artists Rights Society (ARS), New York/Pro Litteris, Zürich

Heinrich Kuehn, *Lotte and Edeltrude in the Meadow*, ca. 1908, autochrome, 18 x 24 cm (7 ⅛ x 9 ⅜ in.). The Metropolitan Museum of Art, Gilman Collection, Purchase, Mrs. Walter Annenberg and The Annenberg Foundation Gift, 2005 (2005.100.737).

Ver Sacrum in 1901, to cite just one of countless statements of the sort.[78] Recreating a paradise was also the goal of the *Lebensreformbewegung* (Life-reform movement), in which many of Germany's *Bildungsbürger* were active. They expressed profound dissatisfaction with existing conditions in a very basic way: "It is directed not only against current problems of technological society but also against its conditions in general: technologizing, industrializing, urbanizing. It counters these things with a call to return to a 'natural' or 'organic' way of living in which the ideal of harmony between the individual and the universe is supposed to be realized in naturalness and healthiness."[79]

Heinrich Kuehn identified with this attitude existentially all his life. Despite recognizing that he more or less cut himself off from international relationships by doing so, later he moved farther and farther into the country. His dominant theme for many years—children playing or resting, or naked in the garden—evokes a prelapsarian world that was deeply rooted in the visual canon of the time as Arcadia. Oskar Kokoschka's *Träumende Knaben* (The Dreaming Youths; 1907) could also be included in this iconographic tradition, although in Kokoschka's case the idyll is broken by the accompanying text; the desire for a connection between human beings and nature proves to be fragile, threatened and ultimately threatening as a result of the discovery of sexuality.

Kuehn did not take that step; he persisted in the idea that the complexity of life should not be met with complex interpretations of the world but rather with simple scenarios that convey intimacy and atmosphere to the "refined eye."[80] Later generations would tend rather to use expressions such as "softly dissolving" for the same phenomenon in painting and photography, thus identifying precisely what modernism had an allergic reaction to.[81] They also interpreted the

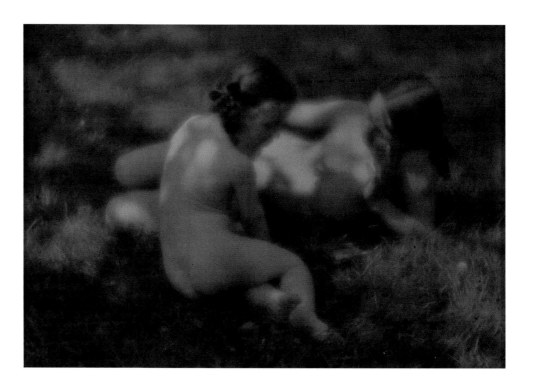

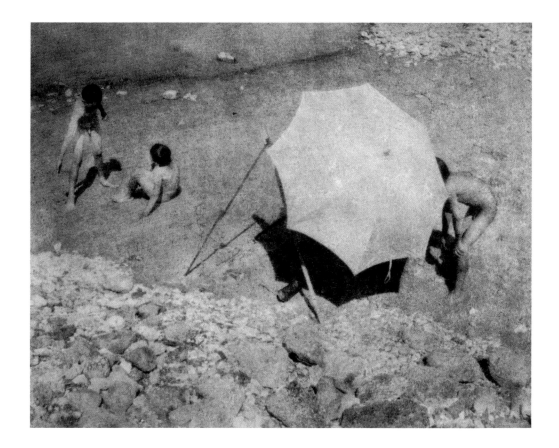

Heinrich Kuehn, *The Painting Umbrella II/ Der Malschirm II*, photograph 1909 or earlier, print after 1911, gum gravure, 23 x 28.9 cm (9 1/16 x 11 3/8 in.). Photoinstitut Bonartes, Vienna

flight from everyday life, which for Kuehn represented a cultural perspective, politically, for example when Leon Trotsky wrote in 1911, after visiting a painting exhibition at the Vienna Secession: "Recoiling from the storm of social passions, [art] ultimately left the broad field of collective human life and withdrew to a voluntary exile—into landscapes, portraits, still lifes, interiors, into idylls and mythology."[82] Not coincidentally, Kuehn considered the "Fall" that had been the ruin of his world, the world of the fin de siècle, to have been social democracy and Cubism in art, as he vehemently explained in his letters.[83]

In fact, at just that time, around 1910, Kuehn was driven from his own paradise by the loss of the greater part of the family's wealth through unfortunate speculations by his brother-in-law in Dresden. After the end of the war, he believed his only option was to sell the house in Innsbruck he had built with such enthusiasm and withdraw to a considerably less expensive neighborhood in a nearby village. At the same time, he tried to use his old connections in the photography industry to benefit financially from his own developments and inventions, which was only partially successful, because his innovations were still based on the needs of the visual ideals of the turn of the century and ignored current innovations. His only regular, though not very profitable, activity was writing articles for international specialist journals, which also led to two textbooks that were primarily technical in orientation and repeated several of his artistic principles, above all the realization of "correct tonal values."

Kuehn's attempt to come to terms with current topics was and remained, despite the change in his social situation, indebted to the ideal of the 1890s: an aestheticizing of life and hence flight from one's own reality. Ivo Kranzfelder summed up this phenomenon: "The principle generally claimed for art of the turn of the century—that it moved from mimesis to the invention of reality—does not apply to art photography. […] Its utopian goal was the transformation of reality into art; the actual result was an aesthetic escapism."[84] For Kuehn, who in the years after 1918 exploited his early scientific training for his inventions, the link between photography's "mechanical-chemical" character and the aesthetic of its product was inseparable. When he reported passionately in 1937 that for him "the developing process was the most fascinating aspect of photography technique," it is clear how important the image that results from the properties of the material was for Kuehn.[85] Reflections on subject matter remained secondary, even though he struggled against new themes and favored traditional motifs. It speaks for itself that one of the last of his surviving negatives was a reproduction, probably dating from the early

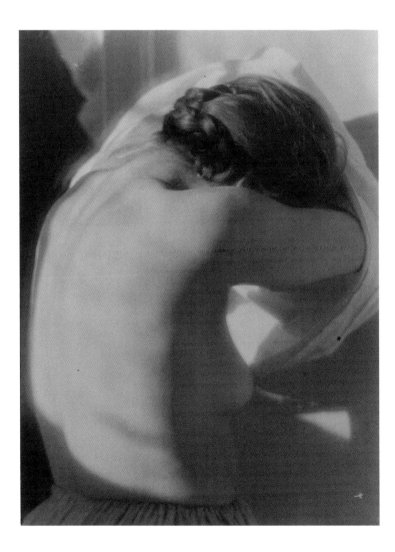

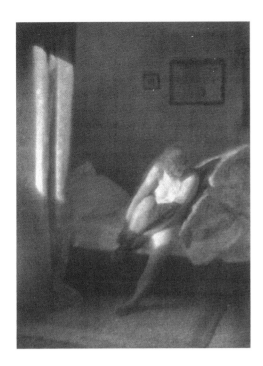

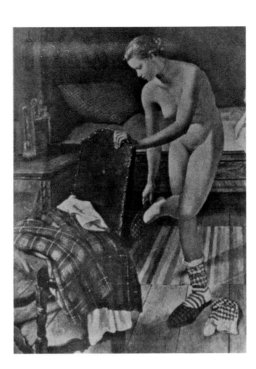

1940s, of Sepp Hilz's *Bäuerliche Venus* (Country Venus), a work that addressed a theme he had often worked on many years, though without approaching his artistic ideals.[86]

The condemnation of the simplified practice of photography took up more space in his writings. His argument ran as follows: If the tonal values rendered are not influenced manually and individually but instead the translation of reality into black and white is left to standard commercial material, then "too much anarchy [dominates] the emotionally established laws of artistic design."[87] He did not stop with the slogan "anarchy" to denounce the decline of ideal values: "We must recognize the danger, sort out the harmful, and through purposeful rebuilding and in part by taking up again the old, now completely forgotten tradition endeavor to reach the heights again gradually."[88] Kuehn was not alone in expressing these desires, whose formulation recalls National Socialist battle cries: for example, the writer Rudolf Borchardt, a friend of Hugo von Hofmannsthal, pursued the project of "restoring the German tradition from the ruins left after it collapsed."[89] With their backward-looking utopia, both Borchardt and Kuehn were deliberately operating outside of what is appraised as modernism from today's perspective. A new praxis and an approach far from the old complicated procedures were by themselves enough to justify rejection. Kuehn complained that the photographers of the New Vision "lacked every self-awareness, every self-criticism"; he believed the movement was dominated by "a leveling of processes and results conditioned by thoughtlessness. [...] The miniature camera demoralizes." In his argument against industrial developing and copying of the film material—in contrast to individual "hard work"—Kuehn even coined the phrase "photographic bolshevism," which, in his view, had to be combated since "collective treatment precludes great and lasting achievements."[90]

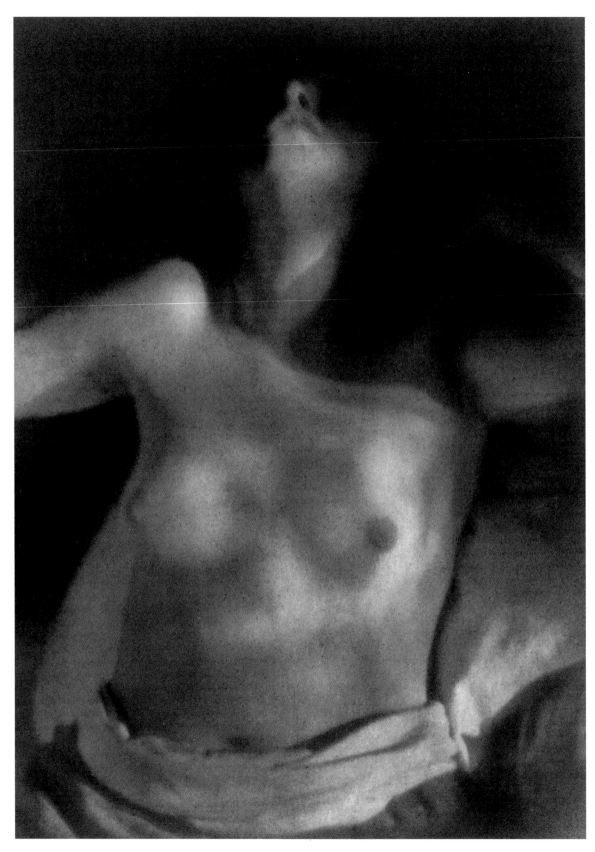

Heinrich Kuehn, *Female Torso in Sunlight/Frauentorso im Sonnenlicht*, ca. 1920, pigment print on tissue, 29.2 x 20.8 cm (11 ½ x 7 ¹⁵⁄₁₆ in.). Collection of Sarah and Gary Wolkowitz

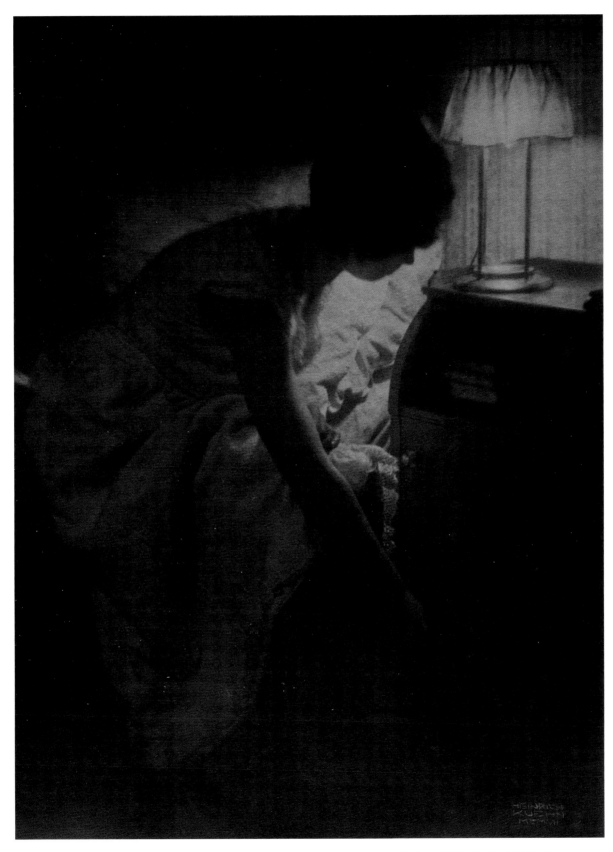

Heinrich Kuehn, *Miss Mary at Her Night Table*, 1907, pigment over platinum print, 39.7 x 29.5 cm (15 ⅝ x 11 ⅝ in.). Collection Raymond E. Kassar, Courtesy Cheim & Read, New York

Wilhelm Hartz, *Internationale Photographische Ausstellung Dresden 1909*, colored lithograph with gold; printer: Wilhelm Hoffmann A. G. Dresden. Höhere Graphische Bundes Lehr- und Versuchsanstalt, Vienna

THE END OF THE PROJECT OF ART PHOTOGRAPHY

The years between 1909 and 1911 can be described as crucial, both in terms of the relationship between Stieglitz and Kuehn and as a turning point in the work of both men. In the end, the goal of a general recognition of the great achievements of art seemed to be within reach; once again there was a meeting of those who saw themselves as an international "spearhead": "Alvin Langdon Coburn called it a 'Grand Pow Wow' when he heard that Steichen, Stieglitz, Frank Eugene and Heinrich Kuehn had spent several days together in Munich in late July of 1909 conducting further experiments with Lumière autochrome plates and generally enjoying one another's company [...] They then proceeded to Dresden to visit the international exhibition, where, thanks to Kühn, their own work was on prominent display."[91] Yet the appearance of the battle having been won was deceptive. Critical voices were already heard: Kuehn was still considered one of the "proven forces," but "Steichen is now what the Austrian 'Kleeblatt' was for the art of photography until Watzek's death and Henneberg's turn from photography." Above all, people noted "the too small number of new works that keep the idea young. [...] We would like to recommend urgently that our new group not persist in its isolation. The risk of having to exhibit fewer good photographs should be regarded as lesser than the risk of not having any followers. Steichen is an unsurpassed master; Kuehn demonstrates his successful efforts in superb portraits, still lifes, and tonal studies; Seeley does so with his exquisite photographs of sunspots. The value of these works would be underestimated if we were to believe that they lose their effect alongside less mature works. [...] In contrast to the enthusiastic pursuits of the 1890s, stillness and monotony dominate today."[92]

A similar criticism could have been made of the large exhibition at the Albright Art Gallery in Buffalo, New York, in 1910, for which Stieglitz provided the majority of the loans in the section for "invited guests." "The aim of this exhibition is to sum up the developments and progress of photography as a means of pictorial expression," announced the accompanying catalogue—and indeed the list of participants with the largest number of exhibits was virtually identical to the one Stieglitz had proposed already in 1898.[93]

In 1911 Stieglitz dedicated an issue of his journal *Camera Work* to Kuehn—one of only five photographers to be honored that way in the magazine's entire run—while his gallery 291 showed watercolors by Pablo Picasso for the first time in the United States. Kuehn's enthusiasm about the issue of the journal was exceeded only by his rejection of the Spanish painter's works. Stieglitz tried in vain to make the connections clear to his friend: For him, Kuehn represented "photography in the purest sense," in contrast to the "so-called photographic art" he rejected. "Now I find that art today consists of the abstracts (without a subject) such as Picasso, and so on, and the photographic. [...] Just as we are standing on the threshold of a new social age, we are also standing before a new expression in art, that of abstraction."[94]

From that time onward, their paths quickly diverged, even though they remained in contact. Whereas Kuehn's masterpieces were primarily produced between 1897 and 1902 and 1905 to 1910, Stieglitz's most important photographic work—now influenced by young artists,

Heinrich Kuehn, *Rubber Tree Plant*, 1929, bromoil print, 29.5 x 21 cm (11 ⅝ x 8 ¼ in.). Lee Gallery

whose absence in 1911 was still being lamented—was still before him. In her assessment of Stieglitz's early work in her analysis of the *Key Set*—his 1,642 works in the National Gallery of Art in Washington—Sarah Greenough came to the characteristic conclusion: "While [Stieglitz] made many critically acclaimed photographs before 1910, many of them were analytical, often didactic, and even reactive, created in response to the ideas and art—especially the paintings—of others. He did not fully clarify what the art of photography entailed and what its relationship to the other arts was until the 1910s, and only then did he become a modern artist—more synthetic, at times intuitive and often highly original."[95] The "art photography" project was finished for Stieglitz, as he wrote in a letter to Kuehn in 1912: "Isn't my work for the cause about finished? Useless to sacrifice time and money simply to repeat oneself—I don't believe in that and therefore I feel far too much the need for my own photography."[96] In retrospect, Kuehn's artistic development seems to have more or less ended around 1912–13—but, by contrast, he did not believe a new age was dawning. Like Stieglitz, he would continue for years to work with earlier negatives, not with a new aesthetic approach but always trying to improve the earlier prints in accordance with the demands for perfection he developed around 1900.

Translated from the German by Steven Lindberg

Heinrich Kuehn, *Mary Warner and Edeltrude on the Brow of a Hill*, ca. 1910, autochrome, 23.8 x 17.8 cm (9 ⅜ x 7 in.). The Metropolitan Museum of Art, New York, Gilman Collection, Purchase, Mrs. Walter Annenberg and The Annenberg Foundation Gift, 2005 (2005.100.370). © The Estate of Heinrich Kuehn/Courtesy Galerie Kicken Berlin

NOTES

1 Alfred Stieglitz, "The Progress of Pictorial Photography in the United States," in Richard Whelan, ed., *Stieglitz on Photography: His Selected Essays and Notes* (New York: Aperture, 2000), 97.

2 Heinrich Kuehn to Alfred Stieglitz, October 11, 1905; Kuehn's letters to Stieglitz are now in the Beinecke Library, Yale University, New Haven, Connecticut.

3 The term "amateur" is applied, not just in photography, to someone who is interested in a certain field as a hobby and not for professional reasons. Alfred Stieglitz emphasized this shared quality in one of his last letters to Heinrich Kuehn, on September 30, 1930, cited in Weston Naef's translation in Weston J. Naef, *The Collection of Alfred Stieglitz: Fifty Pioneers of Modern Photography*, exh. cat. (New York: Metropolitan Museum of Art, 1978), 208.

4 Photographische Correspondenz 24, no. 324 (September 1887), 221.

5 The main contingent of exhibitors was from England, but the exhibition jury performed the great service of recognizing young talent as well, such as Alfred Stieglitz and Hugo Henneberg, who would later become a close friend of Heinrich Kuehn.

6 "Mr. George Davison on the American Works at the Salon," *Camera Notes* 3, no. 3 (1889–1900), 118.

7 Lothar Gall, Walther Rathenau: Portrait einer Epoche (Munich: C. H. Beck, 2009), 21; for an enlightening survey of this phenomenon, see Gall, *Bürgertum in Deutschland* (Berlin: Siedler, 1989).

8 Alfred Lichtwark, "Die Bedeutung der Amateurphotographie" (1894), in Lichtwark, *Erziehung des Auges: Ausgewählte Schriften*, ed. Eckhard Schaar (Frankfurt am Main: Fischer, 1991).

9 An extensive bibliography may be found Monika Faber and Astrid Mahler, eds., *Heinrich Kühn: The Perfect Photograph*, exh. cat. Albertina, Vienna (Ostfildern: Hatje Cantz, 2010).

10 After studies with Hermann W. Vogel in Berlin, in 1890 Stieglitz attended courses by Josef Maria Eder at the recently founded Höhere Graphische Lehr- und Versuchsanstalt in Vienna in order to perfect his photographic technique. He began corresponding with Hugo Henneberg at that time.

11 Karl Moll, unpublished autobiographical manuscript, quoted in Carl Moll: Seine Freunde, Sein Leben, Sein Werk (Salzburg: Welz, 1985), 38.

12 Heinrich Hugo Henneberg, Heinrich Kuehn, and Hans Watzek were the core members of the Kleeblatt; Friedrich Viktor Spitzer was only occasionally considered one of them. See Hugo Haberfeld, "Die Wiener Amateurphotographen," *Die photographische Kunst im Jahre 1906* (1906), 34–48, esp. 41.

13 Kuehn was the artist represented by the largest number of photographs in the exhibition (34); Stieglitz was the only American participant.

14 Details of texts by the authors mentioned may be found in Timm Starl, "BioB ibliographische Datenbank zur Fotografie in Österreich," www.albertina.at.

15 A whole series of the Secession's initiators were closely connected to photography, which has been remarked on in the literature only marginally. For example, a whole series of artists based their works on photographs (e.g., Klimt, Engelhardt), photographed themselves (e.g., Viktor Kraemer), or were close relatives of people in the photography trade (e.g., Carl Moll, whose father, August, ran the largest store in Vienna with photographic supplies). Jakob Emil Schindler, who was admired by everyone, took photographs on his travels.

16 "It is the first attempt at the modern Viennese—à la Hoffmann—interior design in the Tyrol. I readily admit that I have allowed myself to be very influenced by H[offmann], but I have not imitated anything directly but rather studied his ideas, digested them, and then applied them according to the principle. A few fabrics I used are designed by Prof. Moser—I could not go so far as to have fabrics manufactured just for me; Henneberg didn't do that either. But otherwise I have designed and sketches pretty much everything for the house." Heinrich Kuehn to Alfred Stieglitz, December 31, 1905.

17 Stieglitz deliberately chose the name Photo-Secession as a reference to European artistic movements he admired. His friend Joseph Keiley proposed World's Secession as the name for the new international photo association. See Whelan, *Stieglitz on Photography* (see note 1), 170.

18 In 1891 the portfolio Pictures of East Anglian Life by Henry Peter Emerson was exhibited in Vienna for the first time.

19 Alfred Stieglitz, "A Plea for Art Photography in America," *Photographic Mosaics* 28 (1892), 135–37, reprinted in Whelan, *Stieglitz on Photography* (see note 1), 29–30, esp. 30.

20 Egner had a successful exhibition at the Künstlerhaus in 1894 when Kuehn was exhibiting at the Camera Club in Vienna for the first time.

21 See the definition of Stimmungsimpressionismus in Gerbert Frodl and Verena Traeger, eds.,

Stimmungsimpressionismus, exh. cat. (Vienna: Österreichische Galerie Belvedere, 2004), 281–87, esp. 284–85.

22 "Frequent visits to paintings galleries, but above all the first Secession exhibition in Munich inspired me especially. The new expression in the fine arts had a crucial influence on my works." Quoted in [Fritz] M[atthis-Masuren], "Heinrich Kühn," *Photographisches Centralblatt* 5, no. 9 (1899), 161–66, esp. 163. Kuehn mentioned the concept of landscape of the Munich Secessionists and specifically those of Eilif Petersen and Ludwig Dill as a source of inspiration. See F[ritz] Matthies-Masuren, "Hugo Henneberg, Heinrich Kühn, Hans Watzek," *Camera Work*, no. 13 (1906), 21–41, esp. 28.

23 Andrea Winkelbauer, "Frühling im Abendrot: Robert Russ und sein vergessenes Meisterwerk," in Frodl and Traeger, *Stimmungsimpressionismus* (see note 21), 281–87, esp. 284–85.

24 Hans Watzek, "Über das Künstlerische in der Photographie," *Wiener Photographische Blätter* (August 1895), 161–63.

25 Fritz Matthies-Masuren, *Künstlerische Photographie: Entwicklung und Einfluss in Deutschland, Die Kunst: Sammlung Illustrierter Monographien*, ed. Richard Muther, vols. 59 and 60 (Berlin: Marquardt, 1907), 43.

26 Stieglitz, "A Plea for Art Photography in America" (see note 19).

27 Hugo Henneberg, "Erfahrungen über Negative auf Bromsilberpapier," *Wiener Photographische Blätter* (January 1896), 4–6.

28 This exhibition included the first examples of gum bichromate prints by Robert Demachy; reference had been made to the process in *Wiener Photographische Blätter* (July 1894), 128. The process was in fact much older and had been revived by Demachy.

29 Alfred Buschbeck, "Rundgang durch unsere Ausstellung künstlerischer Photographien," *Wiener Photographische Blätter* (February 1897), 36.

30 Fritz Matthies-Masuren, "Hugo Henneberg, Heinrich Kühn, Hans Watzek," *Photographische Rundschau* (1905), 4.

31 Michel Poivert has explained the use of telephoto lens by the Pictorialists in the context of other optical effects; see Michel Poivert, "Degenerate Photography? French Pictorialism and the Aesthetics of Optical Aberration," *Études photographiques*, no. 23 (2009), 207–15, esp. 209; on Gustav Klimt's use of viewfinders and the telescope, which has an effect similar to telephoto lenses, see Anselm Wagner, "Klimt's Landscapes and the Telescope," in Stephan Koja, ed., *Gustav Klimt: Landscapes*, trans. John Gabriel (Munich: Prestel, 2002), 161–71.

32 Heinrich Kuehn, *Technik der Lichtbildnerei* (Halle and der Saale: W. Knapp, 1921), 397. This book was based on texts Kuehn had published since the 1890s.

33 Alfred Stieglitz also used the term: one of the photographs he took in Paris in 1894 (*Au bord de la Seine*) was later renamed *A Decorative Panel*. See Sarah Greenough, *Alfred Stieglitz: The Key Set; The Alfred Stieglitz Collection of Photographs*, 2 vols., exh. cat. National Gallery of Art, Washington, DC (New York: Harry N. Abrams, 2002), 1, xx.

34 "Wiener Camera Club," *Ver Sacrum* 1898, no. 4, 26.

35 "Künstlermonographie," supplement to *Kunst: Halbmonatsschrift für Kunst und alles Andere* 1904, no. 6, 2.

36 Vasily Kandinsky, "Die Wunder der Photographie" (1899), quoted in Ulrich Pohlmann, "Symbolism and Pictorialism: The Influence of Eugène Carrière's Paintings on Art Photography around 1900," in *Impressionist Camera: Pictorial Photography in Europe, 1888–1918*, exh. cat. Saint Louis Art Museum (London: Merrell, 2005), 87–92, esp. 88.

37 Alfred Stieglitz, "The Progress of Pictorial Photography in the United States," in *American Annual of Photography and Photographic Times*, Almanac for 1899, reprinted in Whelan, *Stieglitz on Photography* (see note 1), 97–99, esp. 97.

38 Ibid., 99.

39 Greenough, *Alfred Stieglitz* (see note 34), 1: xix.

40 Stieglitz, "The Progress of Pictorial Photography in the United States" (see note 38), 99.

41 Joseph Keiley, "Pictorial Photography in America and the Photo-Secession," typescript, ca. 1906, 22 pp., box no. 99, folder 2049, Alfred Stieglitz/Georgia O'Keeffe Archive, YCAL MSS 85, Beinecke Library, Yale University, p. 17.

42 It is reasonable to assume that Stieglitz destroyed most of his gum bichromate prints himself after 1910, when his ideas of photography as an art had changed; see Greenough, *Alfred Stieglitz* (see note 33), 1, x.

43 Eugen Kalkschmidt, "Die Londoner Jahresausstellungen," *Photographisches Centralblatt* 8, no. 23 (1902), 486–94, esp. 490.

44 Alfred Stieglitz, "Some Impressions of Foreign Exhibitions," *Camera Work* 8 (October 1904), reprinted in Whelan, *Stieglitz on Photography* (see note 1), 165–70, esp. 166.

45 Heinrich Kuehn to Alfred Stieglitz, October 11, 1905.

46 In 1910 in his last large retrospective on Pictorialist photography, in Buffalo; see Central File Reports, J. Paul Getty Museum, which was kindly provided to me by Paul Martineau,

47 Greenough, *Alfred Stieglitz* (see note 33), 1, x.

48 A sense of the collection of Heinrich Kuehn's photographs that Stieglitz assembled over the course of their friendship may be found in Naef, *The Collection of Alfred Stieglitz* (see note 4), 402–9. In fact, however, Stieglitz had many more photographs by Kuehn, which are now in museums in Chicago, Rochester, and Washington, DC.

49 See Katherine Hoffman, *Stieglitz: A Beginning Light* (New Haven: Yale Univ. Press, 2004), 103.

50 Ibid., 221.

51 Alfred Stieglitz, "How the Steerage Happened," *Twice a Year* 8–9 (1942), reprinted in Whelan, (see note 1), 194–96, esp. 195.

52 Heinrich Kuehn to Alfred Stieglitz, October 11, 1905.

53 Alfred Stieglitz, "My Favorite Picture," in *Photographic Life* I (1899), reprinted in Whelan, *Stieglitz on Photography* (see note 1), 61.

54 Andreas Gruber, "Heinrich Kühn's Photographic Processes," research project, see glossary in the present volume.

55 Fritz Matthies-Masuren, "Die Photographie im Jahr 1906," in Matthies-Masuren, *Künstlerische Photographie* (see note 25), 10.

56 Eugen Kalkschmidt, "Die Amerikaner," quoted in Matthies-Masuren, *Künstlerische Photographie* (see note 25), 95.

57 Heinrich Kuehn, "Klarheit!" in *Das deutsche Lichtbild: Jahresschau* (1937), T 11–T 18, esp. T 14.

58 Kuehn, *Technik der Lichtbildnerei* (see note 32), 404ff. The reference to Hill was no coincidence; Kuehn did have examples of his work at that time, and Stieglitz too admired this Scottish pioneer of photography: the issue of *Camera Work* that preceded the one in which Kuehn and his friends first appeared was dedicated to Hill.

59 Kuehn, *Technik der Lichtbildnerei* (see note 32), 17–18.

60 Heinrich Kuehn to Alfred Stieglitz, October 11, 1905.

61 Stieglitz, "A Plea for Art Photography in America" (see note 19), 30.

62 Heinrich Kuehn to Alfred Stieglitz, March 19, 1923.

63 Kuehn, *Technik der Lichtbildnerei* (see note 32), 389.

64 Ibid., 28.

65 Ibid., 325.

66 Heinrich Kuehn to Alfred Stieglitz, September 7, 1907.

67 Alfred Stieglitz, "The New Color Photography: A Bit of History," *Camera Work* no. 20 (October 1907), 198–206, esp. 201.

68 Ibid. p. 198.

69 Examples are found in the following collections today: Metropolitan Museum of Art, New York; J. Paul Getty Museum, Los Angeles; National Gallery of Art, Washington; Beinecke Library, Yale University, New Haven; Art Institute, Chicago; private collection, Munich.

70 In September, a higher-quality supply arrived in the Tyrol: "What a pity your emulsion in Tutzing was not like this one." Heinrich Kuehn to Alfred Stieglitz, September 9, 1907.

71 Heinrich Kuehn, "Zur Technik des Autochromverfahrens," *Photographische Rundschau* (1907), 261 67, esp. 265. See also Kuehn's commentaries therein on Steichen's suggestions for improvements.

72 See *Alfred Stieglitz; Photographs from the J. Paul Getty Museum, In Focus* (Malibu, CA: J. Paul Getty Museum, 1995), 118. Although many of the surviving photographs from Tutzing are from Alfred Stieglitz's collection, given the practice among these friends of sharing photographs, that cannot be taken as proof that he was the author of most of these photographs.

73 Langdon Coburn to Alfred Stieglitz, quoted in Penelope Niven, *Steichen: A Biography* (New York: Clarkson Potter, 1997), 308.

74 Kuehn, Technik der Lichtbildnerei (see note 32), 402–3.

75 Ibid.

76 Ibid., 17–18.

77 Hugo von Hofmannsthal to Hermann Bahr, 1891, quoted in Ursula Renner, "'Details sollen sein wie jener Blitz bei Dickens': Photopoetische Reflexe um 1900," in Helmut Pfotenhauer, Wolfgang Riedel, and Sabine Schneider, eds., *Poetik der Evidenz: Die Herausforderung der Bilder in der Literatur um 1900* (Würzburg: Könighausen & Neumann, 2005), 103–27, esp. 113.

78 Ernst Stöhr, "Die Malerei unserer Zeit," *Ver Sacrum* no. 9 (1901), 157.

79 Janos Frecot, "Die Lebensreformbewegung," in Klaus Vondung, ed., *Das wilhelminische Bildungsbürgertum: Zur Sozialgeschichte seiner Ideen* (Göttingen: Vandenhoeck & Ruprecht, 1976), 138–52, esp. 139.

80 Georg Fuchs, "Die Photographie und die Kultur des Auges," *Die photographische Kunst im Jahre 1905* 4 (1905), 16–32, esp. 29.

81 Theodor W. Adorno, *Über einige Relationen zwischen Musik und Malerei: Die Kunst und die Künste, Anmerkungen zur Zeit* 12 (Berlin: Gebr. Mann, 1967), 34. For example, in 1932 Anselm Adams remarked on an opportunity to look at Stieglitz's historical collection: "I was impressed with the historic aspect of the Photo-Secession prints, but found it very hard to accept the

esthetic of most what I saw […]. [They] had a fuzzy artiness that did not interest me." Quoted in Naef, *Collection of Alfred Stieglitz* (see note 3), 238.

82 Leon Trotsky, "Zwei Wiener Ausstellungen im Jahr 1911," quoted in David Frisby, ed., *Georg Simmel in Wien: Texte und Kontexte aus dem Wien der Jahrhundertwende* (Vienna: WUV, 2000), 217–24, esp. 224.

83 Heinrich Kuehn to Alfred Stieglitz, December 16, 1911, among others.

84 Ivo Kranzfelder, "Natürlicher Hang zum Künstlichen: Einige Bemerkungen zur Kunstfotografie um 1900 und ihrer 'Modernität,'" *Fotogeschichte: Beiträge zur Geschichte und Ästhetik der Fotografie* no. 58 (1995), 55–62, esp. 59–60.

85 Kuehn, "Klarheit!" (see note 57), T 16.

86 Hilz was one of Adolf Hitler's favorite painters; see Ernst Klee, *Das Kulturlexikon zum Dritten Reich: Wer war was vor und nach 1945* (Frankfurt am Main: S. Fischer, 2007), 247.

87 Kuehn, "Klarheit!" (see note 57), T 15.

88 Ibid., T 11.

89 Rudolf Borchardt, *Reden* (Stuttgart: Klett-Cotta, 1955), pp. 230-253, esp. 250.

90 Kuehn, "Klarheit!" (see note 57), T 11–T 12.

91 Niven, *Steichen* (see note 73), 308. Kuehn and Fritz Matthies-Masuren were invited to co-curate a section at the *Internationale Photographische Ausstellung* in Dresden; they had Stieglitz choose the American entries. The exhibition was titled *Internationale Vereinigung der Kunst Photographen*, and it represented the only manifestation of the elite group that Kuehn and Stieglitz had dreamed of establishing.

92 Anonymous, *Die photographische Kunst im Jahre 1909* (1909), 1–3.

93 Stieglitz sent both early, large-format works by Kuehn to Buffalo as well as more recent works, but the commentary in the catalog makes it clear that Stieglitz regarded the year 1904 as the crucial turning point in Kuehn's oeuvre. See *Catalogue of the International Exhibition, Pictorial Photography*, exh. cat. (Buffalo, NY: Buffalo Fine Arts Academy, Albright Art Gallery, 1910), n.p. The list of artists was nearly the same as proposed in: Alfred Stieglitz, "The Progress of Pictorial Photography in the United States" (see note 1).

94 Alfred Stieglitz to Heinrich Kuehn, October 14, 1912, private collection, Innsbruck. Stieglitz laments in his letter that he cannot express himself more clearly in German.

95 Greenough, *Alfred Stieglitz* (see note 33), 1: xii.

96 Alfred Stieglitz to Heinrich Kuehn, October 14, 1912, quoted in Naef, Collection of Alfred Stieglitz (see note 3), 4.

Heinrich Kuehn, *The Painter's Table*, ca. 1908,
autochrome, 18 x 24 cm (7 ⅛ x 9 ½ in.).
Courtesy of George Eastman House,
International Museum of Photography and Film

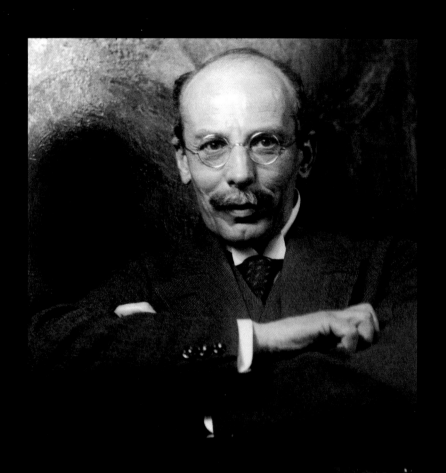

HEINRICH KUEHN

Life and Work: A Biographical Sketch

ASTRID MAHLER

1866–90

Carl Christian Heinrich Kuehn was born in Dresden on February 25, 1866, to Christian Heinrich Kuehn (1825–93) and Anne Sophie Conradi (1826–1912). Kuehn's father made a considerable fortune as a wholesale merchant. His grandfather, Christian Gottlob Kuehn, and his uncle, Hermann Hultzsch, were both sculptors, and Heinrich attributed his interest in the fine arts to their influence.[1]

After graduating from secondary school in March 1885, he enrolled to study medicine at the Universität Leipzig (University of Leipzig). This was followed by studies at the Universität Freiburg im Breisgau (University of Freiburg im Breisgau) and in Berlin in 1887, where by his own account he learned microscopic photography under Robert Pfeiffer at the Institut für Hygiene (Institute for Hygiene). In 1888 he went to Innsbruck and enrolled in the department of medicine. He would remain in the Tyrol for the rest of his life. Until 1890 Kuehn pursued microscopic research and took numerous microscopic photographs of medical slides for the innovative diagnostician Adolf Posselt.

Heinrich Kuehn, *Hofgarten in Autumn/Hofgarten im Herbst*, 1906, platinum print, 16.5 x 29.3 cm (6 ½ x 11 ½ in.). Photoinstitut Bonartes, Vienna

Opposite:
Heinrich Kuehn, *Self-Portrait*, ca. 1930, after original negative

1891–99

Around 1890 Kuehn abandoned his studies without earning a degree. Thanks to an annual financial allocation from his father, he was able to pursue his interests exclusively. He began to photograph his extended mountain hikes, reporting on them to the Alpenverein (Alpine Club) and publishing his first texts and photographs. Around 1891 he completed a two-month photography tour of Dalmatia and Herzegovina with the alpinist and later explorer of Africa Robert Hans Schmitt. In Ragusa (now Dubrovnik, Croatia), Kuehn met the Austrian officer Giuseppe Pizzighelli, a founding member of the Camera Club in Vienna, who introduced him to the technique of platinum printing.

When Kuehn's father died in 1893, Heinrich inherited the family fortune. He intensified his activity on the amateur photography scene: in 1894 he participated in four photography exhibitions for the first time, including the Photographic Section of the Milan International United Exhibitions. This was also attended by Alfred Stieglitz, who was struck by Kuehn's work for the first time.[2]

In November 1894 Kuehn married Emma Rosa Katzung (1870–1905). In December the couple traveled to Vienna on their honeymoon. At the Camera Club, where he participated in an

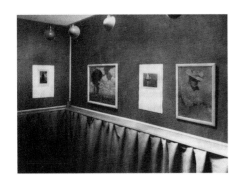

Alfred Stieglitz, View of the exhibiton *Austrian and German Work: Heinrich Kuehn, Hugo Henneberg, Hans Watzek, Theodor and Oscar Hofmeister* in the Gallery of the Photo-Secession in New York, 1906. The two smaller prints are by Watzek, the larger ones by Kuehn.

Heinrich Kuehn, *The Kuehn Villa in Innsbruck*, ca. 1906, after original negative

exhibition, he met the members Hugo Henneberg and Hans Watzek. Immediately on returning home, Kuehn took the photograph he called his "first artistic photograph."

In May 1895, Kuehn was accepted into the Camera Club. At the same time, he came into contact with the Gesellschaft zur Förderung der Amateur-Photographie in Hamburg (Society for the Advancement of Amateur Photography)—the most progressive association on the German amateur scenes—as a corresponding member. A year later the Linked Ring, England's most ambitious amateur association, made him a member.

In December 1895 Kuehn, Henneberg, and Watzek were impressed by five gum bichromate prints presented at the Camera Club by the French amateur photographer Robert Demachy. In February 1896 Kuehn presented a portrait printed with the gum process for the first time; in October his first essays on the subject were published in the club's journal, *Photographische Mitteilungen* (Photographic Reports). In an intense exchange of letters and in meetings, Henneberg, Kuehn, and Watzek came up with gum bichromate prints and even tri-color gum prints.

Beginning in mid-1897, Kuehn, Henneberg, and Watzek called themselves "Kleeblatt" (Cloverleaf) or "Trifolium" (Trefoil) to demonstrate their association as friends and professionals. They usually signed their works (and their letters) with a stylized symbol of a three-leaf clover. They undertook numerous photographic travels together. Following an excursion to Hamburg on which they were very probably joined by Watzek as well, Henneberg and Kuehn spent April 1897 in Venice; in July they took the first Cloverleaf journey to Lake Constance. In August 1898 they traveled together on the Danube. Even when he was traveling alone, Kuehn chose destinations popular among contemporary German-speaking artists: in addition to Venice, that was true of Holland, Lake Garda, and the Dachau region.[3]

In 1898 the Verein bildender Künstler Münchens Secession (the Munich Secessionists) invited amateur photographers to participate in the *Erste Internationale Elite-Ausstellung künstlerischer Photographien* (First International Elite Exhibition of Pictorial Photographs). Kuehn submitted the most exhibits of all the participants; Alfred Stieglitz was the only American photographer represented.

1900–1909

Around 1900 Heinrich Kuehn was at the height of his fame in Europe. His photographs were shown in exhibitions by the most renowned amateur clubs.[4] In 1902 the Vereinigung bildender Künstler Österreichs Secession (the Austrian Secessionists) invited amateur photographers to exhibit for the first time. Kuehn, Henneberg, Spitzer, and Watzek participated in the exhibition. The following year the Künstlerbund Hagen (Hagen Artists' Association) in Vienna also opened its spaces to amateur photographers.

Kuehn was no longer very interested in the constantly growing amateur scene and its (in his words) "average" production of photographs. In collaboration with the Deutsche Lichtbildnervereinigung (German Photographer's Association or German Photography Assocation), he and his friends planned an amateur association that would provide a connection to selected international

photographers. The death of Hans Watzek in May 1903 put an end to the project. Hugo Henneberg turned from photography to printing. Hence Kuehn's most important contacts to the life of the Camera Club in Vienna were lost. He decided to become simply a corresponding member.

In mid-August 1904 Kuehn met with Alfred Stieglitz for the first time, although they had been corresponding occasionally since 1899. Kuehn made portraits of his new friend in his own home and outdoors. They discussed the idea of an elite international association of amateurs.

The correspondence between Kuehn and Stieglitz, which spanned more than thirty years, provides insight into how both men worked, into their appreciation of colleagues, of the general developments in the amateur photography movement, and of their personal mindsets.[5] This written contact was important for Kuehn in particular.

Following the birth of Charlotte or Lotte (1904–1993)—their fourth child, after Walther (1895–1970), Edeltrude (1897–1980), and Hans Heinrich Hugo (1900–1970)—Emma Kuehn's long ailment, which had been virulent for some time, grew worse. On October 15, 1905, she died of tuberculosis. Kuehn's previously fruitful publication activity ceased and he produced only a few photographs.

In early 1905 construction began on a Jugendstil house at Richard-Wagner-Straße 6 in Innsbruck (Saggen); it was ready for occupancy in January 1906. Since 1904 the twenty-three-year-old Englishwoman Mary Hannah Warner (1881–1933) had worked for the Kuehn family as a nanny. Affectionately called "May" or "Mamay," she became a surrogate mother for the four children and remained in the home until her death in 1933. Kuehn never remarried; presumably Warner played the role of an unofficial life partner. At the very least she became the crucial model for his photographs, along with and together with his children.

Beginning in 1905 Kuehn regularly made portraits for commercial purposes. He recruited his clients from the upper middle classes, the minor nobility of the Tirol, and from the circles of fellow artists.

In 1905 Kuehn participated in the organization of the exhibition initiated by the Camera Club: the *Internationale Ausstellung ausgewählter künstlerischer Photographien* (International Exhibition of Selected Pictorial Photographs) at the Galerie Miethke (Vienna's most important gallery for contemporary art, which was directed by Carl Moll). Alfred Stieglitz chose the American entries.

In 1906 Kuehn's work was presented in America for the first time. Stieglitz organized the exhibition *Austrian and German Work: Heinrich Kuehn, Hugo Henneberg, Hans Watzek, Theodor and Oscar Hofmeister*, held at the Gallery of the Photo-Secession in New York, April 7 to 28. Some of the works traveled from there to Philadelphia. Kuehn's first solo exhibition was held at the renowned Galerie Schulte in Berlin during this same time.

Kuehn worked all his life to optimize camera technology and to improve the film stock and the printing process. He repeatedly asked Stieglitz to use his contacts to offer Kuehn's camera adaptations (such as his design for a movable focusing screen frame) to American companies.[6] Stieglitz in turn provided Kuehn with the latest products from the American market, such as Smith lenses, which had a soft-focus effect that Kuehn used very frequently.

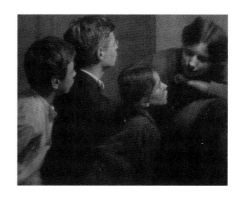

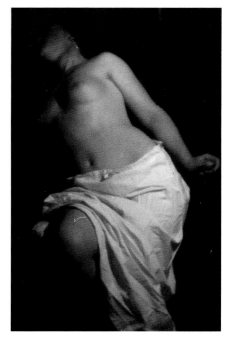

Heinrich Kuehn, *The Kuehn Children*, 1913, gum bichromate over platinum print on Japanese paper. Private Collection

Heinrich Kuehn, *Female Torso (Mary Warner)*, ca. 1908, after original negative

Heinrich Kuehn, *Edward Steichen*, July 1907, platinum print on Japanese paper, 28.5 x 22.5 cm (11 ¼ x 8 ⅞ in.). Private Collection

In July 1907, in Tutzing in Bavaria, Kuehn met Edward Steichen for the first time, along with Stieglitz and Frank Eugene. Steichen had brought with him from Paris the first commercially available autochrome plates—the first commercial color process—which the four artists used for various experiments. Working with autochrome plates represented an extraordinary broadening of the possibilities of photography for Kuehn. He used them until around 1918.

After their stay in Tutzing, Steichen visited Kuehn at home in Innsbruck for two days. Stieglitz also came to the Tyrol. Their friendship grew stronger.

Kuehn and Fritz Matthies-Masuren organized a selection of works by international art photographers for a large-scale exhibition in Dresden in 1909 that covered the entire thematic spectrum of photography; once again Stieglitz also served on the jury. That occasion was also supposed to lead, finally, to the founding of an international association, but it came to nothing as a result of quarrels and dissension with certain Pictorialists. Kuehn and Stieglitz also had their differences, but they managed to resolve them in Munich that summer. That was the final meeting of the two friends.

1910–19

At the beginning of the decade, Kuehn enjoyed the height of his international attention when Stieglitz dedicated an issue of *Camera Work* to him in 1911. That year he also had a large solo exhibition at the avant-garde Galerie Thannhauser in Munich.

Poor investments by his brother-in-law, the Dresden architect Richard Nicolaus, resulted in the near complete loss of the Kuehn family fortune. The resulting financial difficulties led him to apply unsuccessfully to various institutions for work; these include the Graphische Kunstanstalten F. Bruckmann A.G. in Munich, where Alfred Stieglitz had reproductions made for *Camera Work*, and as professor of the Graphische Lehr- und Versuchsanstalt in Vienna, which Stieglitz had attended in 1890. But three years later when he received an offer to succeed Frank Eugene in the chair for photography at the Lehr- und Versuchsanstalt für Photographie, Lichtdruck und Gravure (School for Photography, Prints, and Engraving) in Munich, he turned it down. His finances had stabilized somewhat in the meanwhile, and he planned to establish a state chair for art photography in Innsbruck. Following unsuccessful negotiations with the ministry responsible, he began to offer courses on his own. His Lichtbildnerschule (Photographers' School) was in existence only from autumn 1914 to June 1915, when his assistant, Peter Paul Atzwanger, had to join the military as result of the war.[9]

Like many of his compatriots, Kuehn welcomed the beginning of the First World War with complete conviction. Kuehn remained ambivalent about the status of his nationality, however; after the war ended and the monarchy broke down, he considered becoming an Austrian citizen. In fact, however, he remained a German citizen, because he neglected (whether deliberately or not) to apply for a residence permit in Innsbruck.

During and after the war, Kuehn's contacts to the photographic scene were all business and characterized above all by his contributions to professional journals. He also worked intensely with the photographic industry and offered expert opinions to companies.

Private exchanges with colleagues were kept to a minimum. Even his correspondence with Stieglitz was interrupted between 1916 (when America entered the war) and the end of the war. Henneberg, Kuehn's old comrade in arms, died in 1918.

After a break from publication for several years,[10] Kuehn published a series of articles titled "Einführung in die Technik der bildmäßigen Photographie" (Introduction to the Technique of Pictorial Photography) in the *Photographische Rundschau* from 1917 to 1919. His articles led to the publication of his first book two years later: *Technik der Lichtbildnerei* (Photographic Technique). In addition to provide an overview of the requirements for photographs, an analysis of the materials, and a discussion of various printing techniques, he continued his discussion of tonal values. Around 1915 he began to produce separate negatives for lights and shadows and then print them together. He worked for years by this method, which he initially called his "photographic method to cope with large contrasts in brightness."

After the war it became too expensive to live in Innsbruck; years earlier he had already been forced to rent out his studio spaces. In March 1920 he sold his villa and moved to a neighborhood in Rietz in the Upper Inn Valley.

Heinrich Kuehn, *Farmhouse in Tyrol/ Bauernhouse in Tirol*, ca. 1908, autochrome, 18 x 24 cm (7 ⅛ x 9 ½ in.). Österreichische Nationalbibliothek, Bildarchiv, Vienna

1920–29

In 1921 Kuehn purchased a house in Birgitz, a little village near Innsbruck, where he would spend the final years of his life. When Kuehn und Hultzsch, the Dresden-based company that had managed the remainder of the family's wealth, was dissolved in 1923, his period of financial independence was over.[11] Kuehn began to work more intensely on improving the technology for cameras and photosensitive material. He also wrote various essays on a wide range of photographic themes, which often derived from his experiments.

Together with various companies, Kuehn tried to register earlier patents abroad. Kuehn's improvements to the "Studienkamera" (study camera) developed by Hans Watzek and Ludwig David around 1890 were implemented by Stegemann in Berlin in 1916, and after further adaptations led to the Kuehn-Stegemann Studienkamera-C*, with production beginning in 1927.

Together with Franz Staeble in Munich, he developed the Kuehn-Anachromat, which was introduced to the public in 1928: a lens system that produced soft contours. Rodenstock began marketing the lens three years later under the name Tiefenbildner Imagon.

Photographische Rundschau und Mitteilungen, of which Matthies-Masuren was co-editor, played an important role as a forum for Kuehn, first publishing his photographs and increasingly his technical articles. From 1926 to 1929 he also served as co-editor. He published his second book, *Zur photographischen Technik* (On Photographic Technique), in 1926.

Kuehn no longer described himself as a photographer or artist but rather as a "photochemist/technician." He published photographs only to illustrate his articles.

Beginning in 1924, Kuehn began to participate in exhibitions again, but he only showed older works, which were presented in "historical" or "retrospective" sections. The world of German-speaking amateur photographers esteemed Kuehn as an important historical figure in

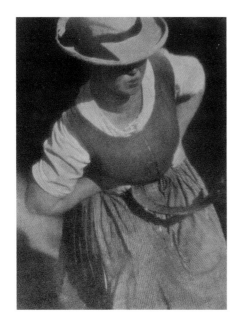

Heinrich Kuehn, *Harvester/Schnitterin*, July 4, 1924, multiple oil transfer print (May 19, 1943), 28.5 x 21 cm (11 ¼ x 8 ¼ in.). Courtesy George Eastman House, International Museum of Photography and Film

the period around 1900 when amateur photography had become established, but otherwise he was seen exclusively as a theorist.

Kuehn's sons—Walther, who would become successful as a painter in Innsbruck, and Hans, an unsuccessful real estate and mortgage agent—were living in Munich at this time. Interactions with his family were dominated by disagreements and differences over finances, which Hans's activities had ruined once and for all. His daughter Lotte moved to Innsbruck in 1929 after marrying. Kuehn lived with his daughter Edeltrude and Mary Warner in Birgitz. In the letters from this period that survive, Kuehn limited himself, as he had in earlier letters, to professional issues; of his private life he mentioned Mary Warner's grave illness only to Stieglitz.

1930–44

Kuehn's technical innovations reached a climax and at the same time came to an end: his "photographic method to cope with large contrasts in brightness"—also known as "Syngraphie" (syngraphy)—was patented in 1930, first in Germany and then in Austria. In the simplified version of syngraphy, only a single negative is exposed. The "photographic film coated on two sides" necessary for this method was patented. None of his technical developments earned him much money.

His final correspondence with Stieglitz on January 1, 1931, represented a turning point. Only a few personal acquaintances—mostly colleagues such as Adalbert Defner—visited him in Birgitz, but he received numerous official honors, including honorary membership in the Photographische Gesellschaft in Vienna, and membership of the Verehrliche Vereinigung Bildender Künstler Innsbruck (Worshipful Assembly of Artists). The Philosophische Fakultät (School of Philosophy) at Innsbruck University awarded Kuehn an honorary doctorate in 1937 in recognition of his services to scientific and art photography.[12] Kuehn was supposed to have received his award in 1933–34. But the ministry initially rejected the award based on an anonymous communication that accused Kuehn of anti-Austrian views.[13] Apparently he joined the Vaterländische Front (Fatherland Front), an Austrian fascist association, in order to refute this accusation. In fact, however, he did not conceal his "pan-German attitude" and shortly after the honorary doctorate was awarded he applied for a German passport. He hailed the "annexation" of Austria to Germany and on June 24, 1938, applied for membership in the National Socialist Party.

In the 1930s Kuehn published as many as six articles per year in German-language journals. His final essay, "Klarheit!" (Clarity!), was published in 1937 in *Das Deutsche Lichtbild*. In it he unwaveringly advocated his conservative attitude toward photography and used the forum to present his research into the negative process. Despite the limitations imposed by old age, he continued to pursue his related research tirelessly until shortly before his death.

Mary Warner's death in 1933 at the age of 52 affected Kuehn profoundly. Eleven years later, on September 14, 1944, Kuehn died in Birgitz at the age of 78 from gastrointestinal poisoning and organ failure.

NOTES

Heinrich Kuehn's unpublished papers contain many materials to aid in compiling a biography: in addition to family documents, there are letters, studio notebooks, and a manuscript curriculum vitae dated January 7, 1934. Another curriculum vitae from October 9, 1938, has been published in Timm Starl, "Ein Vorkämpfer für die deutsche Kultur," *Fotogeschichte* 8, no. 28 (1988), 49–54, esp. 50. These curricula vitae are cited in the notes as M 1934 and M 1938, respectively. His letters to Alfred Stieglitz are in the Beinecke Library, Yale University, New Haven, Connecticut. Additional correspondence is held in the Fotomuseum im Münchner Stadtmuseum and the Agfa-Fotohistorama in the Museum Ludwig in Cologne.

1 M 1934.
2 Until the beginning of the First World War, Kuehn participated in four to five national and international exhibitions every year.
3 Stays in Venice in 1897 (with Henneberg), 1898, 1899, and 1907 are documented. Kuehn spent a few weeks in Holland in 1897, 1898, 1901, and 1904, primarily in Katwijk aan Zee; in 1904 he visited Bruges in Belgium as well. Stays with Henneberg and Watzek on Lake Garda are documented at least once prior to 1903, then again with Henneberg in 1906 and on his own in 1907. Travels to Dachau and Worpswede are documented around 1895 and 1901, respectively.
4 Kuehn's unpublished papers include a diverse correspondence with international greats of this scene, such as James Craig Annan, George Davison, Robert Demachy, Adolf De Meyer, Alvin Langdon Coburn, Reginald Craigie, Frank Eugene, and Gertrude Käsebier, written in the context of exhibitions. The main recipient of his correspondence after the death of Hans Watzek until 1931 was Alfred Stieglitz.
5 His correspondence with Stieglitz began with a postcard dated January 3, 1899; after an interval they resumed their sparse correspondence in 1902. Only from 1904, after they had met, did their written exchange become more frequent.
6 Neither Folmer & Schwing nor Kodak showed any interest in producing it.
7 An autochrome is a kind of color slide that can only be viewed with backlighting or as a projection.
8 Galerie Thannhauser, Munich, March 16–31, 1911.
9 Heinrich Kuehn to Alfred Stieglitz, July 16, 1915. Atzwanger, who had trained at the Graphische Lehr- und Versuchsanstalt in Vienna, would later teach there and become one of the leading Austrian photographers between the wars.
10 Kuehn did not publish any articles from 1910 to 1915.
11 Document in a private collection.
12 See Ehrendoktorats-Akt Heinrich Kühn, 1937 (Universitätsarchiv Innsbruck).
13 Ibid.

GLOSSARY OF PHOTOGRAPHIC TERMS

ANDREAS GRUBER

AUTOCHROME

A color transparency on glass, first invented by Louis Lumière and produced via an additive color process; in use from 1907 to 1935. An autochrome is produced using a glass plate coated with a mosaic of very fine color filters, which are made from transparent grains of potato starch dyed blue, orange, and green. On top of the color filter layer is a panchromatic black-and-white emulsion. This is exposed through the glass and filter layer, so that the colors register in the same way as in color separation negatives, however, in this case side by side as tiny dots on a single photographic layer rather than on three separate negatives. Afterwards, the plate is developed into a negative and then reversed to form a positive, resulting in a black-and-white transparency on top of the color filter layer. When viewed, the black-and-white image selectively prevents light from penetrating certain color elements. Thanks to the additive synthesis of colored light, the original colors of the object in the photograph can be reconstructed by the filters that are not blocked. Autochromes were viewed either by projection or by using transparency viewers.

Kuehn experimented with this process from 1907 until around 1914, and, according to the notes in his journals, he also conducted a few experiments in 1919. Kuehn's preferred sizes for his autochromes were 9 x 12, 13 x 18, and 18 x 24 cm.

BICHROMATE PROCESSES

Besides light-sensitive silver salts, there was another system for producing photographs: Mungo Ponton had discovered in 1839 that if colloids such as gelatin, egg white, or gum arabic are treated with bichromates, they become light-sensitive. When exposed to light, the colloid layer hardens and becomes water insoluble. Pigments can be used to color the colloid emulsion before exposure. In the areas where it has been exposed, the hardened colloid pigment emulsion adheres to the paper; the remaining material can be washed away in warm water, allowing the image to appear. In another approach used to create an image with the bichromate system, the unexposed sections of a non-pigmented colloid emulsion are not washed away, but simply soaked in a water bath. The exposed, hardened areas repel water, but oil-based inks stippled onto the surface adhere to these areas, thereby gradually developing the image. The colors of these pictures are determined by the pigments used. The method often results in painterly effects, which is why it was particularly favored by Pictorialist photographers in the early 20th century.

CARBON PRINT

Bichromate process patented in 1855 by Louis-Alphonse Poitevin and improved by J. W. Swan in 1864; in use until about 1940. In this process, carbon tissue, a paper coated with a pigmented gelatin emulsion, is sensitized to light in a potassium bichromate bath. The tissue is exposed in direct contact with a negative, and the gelatin hardens and repels water in proportion to the intensity of the exposure, while the unexposed areas remain water-soluble. In the developing process, these areas are washed away in warm water and, as the image gradually appears, they form the highlight areas of the photo. However, in order to wash away as much as possible, the exposed gelatin layer is placed in a second water bath and then transferred by pressing the carbon tissue onto a second piece of wet paper, the final image carrier. The hardened sections adhere to that piece of paper, while the non-hardened areas—which are now on top—can be easily dissolved; the transfer paper is subsequently removed in a warm water bath. If one does not start with a reversed negative, the transfer process will produce reversed images. Pigment prints are distinguished by their finely graduated spectrum of tones and their richness of detail. The colors are determined by the pigments used.

Heinrich Kuehn, *Mary Warner, Lotte, and Hans*, 1912–13, autochrome, 18 x 13 cm (7 1/8 x 5 1/8 in.). Österreichische Nationalbibliothek, Bildarchiv, Vienna

Heinrich Kuehn, *Kuehn-Stegemann Studienkamera*, ca. 1927, after original negative

Kuehn's carbon prints were made in different variations of this process in the first decade of the 20th century. In many cases, it is difficult to identify his pigment prints as such, since he also often worked with enlarged paper negatives, so his pigment prints frequently took on the coarse grain of a gum print.

COMBINATION GUM BICHROMATE PRINT

Bichromate process. In 1897, with the objective of increasing the tonal range and thus producing a more three-dimensional image with rich shadows and clear light, Kuehn and his colleagues began making gum prints by superimposing several layers of images that were exposed for different lengths of time from the same negative. After the first layer had been exposed, developed, and dried, another coating of light-sensitive, pigmented gum arabic was brushed on and then processed in the same way, and so on. Four- to five-layer prints, many of them with slightly—or sometimes strongly—altered mixtures of pigments, were not unusual among Kuehn's works. According to the information written on their reverse sides, some of the gum prints even had up to ten layers.

GUM BICHROMATE OVER PLATINUM PRINT

Bichromate process. Wanting to lend some decorative power to the delicate image of the platinum print and to give the pictures better overall coherence by eliminating superfluous elements, minor details, or too many midtones, Kuehn began combining the platinum print with the gum print in 1906. A relatively bright platinum print is coated with hardened gelatin, and on this a fine-grained gum print is produced.

According to Kuehn, this process could be traced back to the Salzburg firm of Würthle & Sohn; he also mentions the American photographer Edward Steichen as an expert in this combination process.

GUM BICHROMATE PRINT

Bichromate process developed by Louis-Alphonse Poitevin and John Pouncy; in general use from 1894 to 1930. This technique is very similar to the carbon print. Instead of gelatin, the light-sensitive emulsion is made of gum arabic mixed with potassium bichromate and pigments. During exposure (in direct contact with the negative), hardening occurs in proportion to the intensity of the light exposure. Non-hardened sections remain water-soluble and can be removed, either by soaking in a water bath, by rinsing, or by being additionally rubbed with sawdust. The gum print is a coarsely grained picture with high gradation—in other words, very narrow tonal range. The colors are determined by the pigments employed. In order to achieve a wider tonal range,

Kuehn, Henneberg, and Watzek developed the combination gum bichromate print.

GUM GRAVURE

A gravure process similar to photogravure and the bichromate process. In order to overcome the "boring smoothness" of photogravure, Kuehn developed the gum gravure in January 1911. The prints made using this process more closely resembled gum bichromate prints than reproductions of photographs. First, a positive paper transparency is made, using the gum bichromate process. In contact with this, a light-sensitive carbon tissue is exposed to sunlight. After being placed in a water bath, the exposed bichromate layer is transferred by pressing the paper onto a copper plate prepared with asphalt dust in an aquatint process. The rest of the process is identical to that of the photogravure. The process was not widely used, since engravers knew almost nothing about making gum prints, and gum print makers had little experience in copper etching.

IMAGON

A soft-focus lens made by Franz Staeble according to Kuehn's instructions. The Staeble works were taken over in 1931 by Rodenstock, which manufactured and sold the lens from 1931 until well into the 1990s as Imagon Tiefenbildner. The Imagon consists of a biconvex condenser lens cemented to a biconcave diffuser lens, each made of a different kind of glass. With the exception of spherical aberration, most of the lens aberrations are corrected to a large degree. The lens is distinguished by its ability to capture an unusual depth of image, while also balancing out strong contrasts between light and dark. Thanks to the spherical aberration, a diffuse image is laid over the sharp image, resulting in the soft-focus. The effect can be controlled by up to six interchangeable perforated aperture diaphragms, which came with the lens. Several variants of the Imagon were produced, with focal lengths ranging from 17 to 48 cm for negative sizes from 6 x 9 to 24 x 30 cm. Sometimes "Imagon" was spelled "Jmagon."

KUEHN ANACHROMAT

Prototype of the Imagon, a soft-focus lens (1:5,4/15–60 cm focal length) with interchangeable perforated aperture diaphragms, calculated and built in 1926 by Munich optician Franz Staeble, according to Kuehn's instructions. The main difference to other soft focus lenses of the period was that the soft focus effect was maintained at any chosen aperture.

KUEHN-STEGEMANN STUDIENKAMERA C

Bellows camera made of wood, constructed according to Heinrich Kuehn's instructions and

marketed between 1927 and 1950. This camera was distinguished by its light weight, as well as by the fact that the focusing screen frame could be tilted in all directions. Another innovation was the use of an optical bench, in the form of a 50 cm long aluminum triangular monorail, on which the focusing screen frame and the lens panel frame could be shifted back and forth. 9 x 12 cm glass and sheet film negatives could be exposed with the Studienkamera C. The camera was preceded by two models: the first, the Stegemann Studienkamera, was specially designed in the mid-1890s by Hans Watzek and Ludwig David for 24 x 30 cm glass and paper negatives taken with a monocle lens. At Kuehn's urging, the improved, second version, with a moveable focusing screen frame, was marketed in 1916.

LEIMDRUCK

Direct bichromate process developed by Heinrich Kuehn. Instead of gum arabic, this process uses hide glue mixed with pigments and ammonium bichromate, which is brushed onto paper that is not too thick. After drying, this light-sensitive emulsion is exposed to sunlight in contact with the negative. Here, however, the negative faces not the colloid emulsion, as is usually the case, but the non-emulsified, reverse side of the paper instead. This means that the glue emulsion is exposed through the back of the paper, which has previously been made transparent by an application of petroleum oil or Vaseline. As a result, the exposed and hardened parts of the image are directly in contact with the surface of the paper, while the unexposed, water-soluble emulsion is on top and can be washed off in a warm water bath. The glue print produces photographs with matte surfaces and powerful shadows, but the highlights are not clear, so that the pictures seem dark and heavy.

Kuehn first publicized this process in 1921, but according to entries in his studio journals, his experiments with it ran from late 1899 to 1908.

MONOCLE

An uncorrected one-element photographic lens, usually a biconcave or convex/concave converging lens, about four to ten centimeters in diameter. Hans Watzek showed the first photographs he had taken with objectives made from eyeglass lenses at the Camera Club in Vienna in 1891. The monocle produces an especially attractive diffusion, the soft focus being the result of the chromatic and spherical aberrations of the lens. The monocle is especially suited to large negatives and portrait photographs. Kuehn recommended focal lengths ranging from 70 cm to one meter, but not under 50 cm (+ 2 diopters). He and his fellow Camera Club members frequently used this kind of objective. The focusing difference made its use somewhat unwieldy, so August von Loehr and Wilhelm Freiherr von Schwind suggested improvements that would make the lens easier to use.

OIL PRINT, OIL TRANSFER PRINT

Bichromate process, publicized by G. E. H. Rawlins in October 1904, in general use from about 1907 until well into the 1940s. In 1911 Robert Demachy rediscovered and further improved the oil transfer print. In this process, the paper is coated with non-pigmented bichromate gelatin emulsion and then exposed in contact with a negative. The exposed areas harden in proportion to the intensity of the exposure. Unlike the carbon print, unexposed, non-hardened areas are not rinsed off in a warm water bath; instead, any excess water is simply removed from the surface. Oil-based ink is then stippled onto the as-yet invisible picture. The ink adheres only to the hardened parts of the gelatin emulsion, but not to the unexposed areas covered with damp gelatin. The pigmented image hereby created can then be dried or transferred to another piece of paper using an intaglio printing press (oil transfer print). The characteristic feature of this process is the coarse-grained image structure it produces. Any color is possible. Since the ink, which is usually harder than the one used in bromoil printing, is stippled on with a brush, the photographer can manipulate the photograph in many ways.

Kuehn began using the oil print process around 1908. However, since the tonal range in an oil print is very limited, around 1915 he began producing his oil transfers by making partial negatives from the same motif with different exposure times and then subjecting them to multiple transfers. This allowed him to produce the spectrum of tones he desired (Syngraphie). From 1915 to the end of his career, the multiple oil transfer print became Kuehn's preferred method to create positives on paper.

OZOTYPE

Bichromate process. Variation of the carbon print, not involving transfers, patented by Thomas Manly in 1898. A negative is copied onto paper coated with a light-sensitive mixture of potassium bichromate and manganese sulfate. This produces a brownish image, which is then rinsed to get rid of the unexposed bichromate. Then it is pressed together with gelatin pigment paper that has been soaked in an aqueous solution of hydrochloric acid, hydroquinone, and copper sulfate. After about an hour, it is developed in a warm water bath. The areas of the image containing chromium react with the acids, which hardens the gelatin pigment, so that a pigmented image gradually forms on top of

the bichromate image. The non-hardened areas are rinsed off with warm water.

Kuehn experimented with this process from 1902 to 1904, but he ultimately rejected it, because, in his opinion, it produced gloomy pictures with overly dense shadows. In addition, some of the steps in the process, such as rinsing the bichromate, were difficult to control, since, depending on the paper, the image could be weakened by soaking it for too long.

PHOTOGRAVURE

Photomechanical form of intaglio printing, which became practicable when the Viennese Karl Klič refined the earlier methods of Joseph Nicéphore Niépce and William Henry Fox Talbot in 1879. A carbon tissue—i.e. paper sensitized with a commercially available bichromate gelatin pigment emulsion (bichromate process)—is exposed in contact with a positive transparency. After soaking the exposed paper in a water bath, the bichromate emulsion is pressed onto a copper plate that has been prepared using the aquatint process and dusted with resin. The paper can be removed in the warm water and the areas where the gelatin is unhardened can be washed away, like in a carbon print. As a result, a gelatin relief remains on the copper plate, which is etched by placing it in a solution of ferric chloride and ammonia. Depending on the thickness of the gelatin relief, the acid reaches the copper at different speeds, which causes the resultant etching to be of different depths. After the copper plate has been cleaned, oil-based printing ink is applied to its surface, and the image on the plate can be transferred to paper using an intaglio printing press.

PLATINUM PRINT

Non-silver process described and patented in 1873 by William Willis; in use until around 1930. The process is based on the light-sensitivity of ferric oxalates, which are capable of reducing platinum salts to metallic platinum. The platinum particles that create the image are actually in and on the uppermost layer of the paper fibers. There is no binder layer. The process therefore produces matte surfaces. Different processing methods result in different colors in a platinum print, ranging from a cool, bluish-black to warm brown tones. To this day, no other process can rival the platinum print for its wide spectrum of mid-tones. Despite this, the process did not remain in general use, since the light-sensitive paper could not be preserved for very long. The process was also very expensive, since the price of platinum was about fifty-five times that of silver. During World War I, platinum became even more expensive and availability was limited.

Kuehn produced platinum prints from 1894 to 1896 and then from 1903 until around 1914. He preferred brownish-black and brown tones for his platinum prints, which he achieved by developing his pictures in a mercury chloride solution.

PRINTING-OUT PROCESS

The excess of silver nitrate in most nineteenth-century photographic paper for black-and-white processes (which used silver for the image-forming particles) meant that the composition of the light-sensitive layers was different to that used in today's developing-out process, in which a chemical reaction produces the image. Light-sensitive printing-out-paper is placed in a contact-printing frame in direct contact with the negative and then exposed to sunlight until the positive image appears of its own accord, without the need for chemical development. The positive and negative are thus the same size.

Heinrich Kuehn also used this method to make his albumen prints, gum prints, platinum prints, and many others. In order to produce his large-format gum or carbon prints he made enlarged paper negatives from interpositives of the same size as the final print. On the reverse of his photographs one often finds information about the exposure times, sometimes in minutes (') or seconds ("), but most frequently in degrees (°). Degrees refer to the units on the light meter Kuehn used in the printing-out process.

SYNGRAPHIE

A photographic process developed to manage strong contrasts of light and shadow. The goal of Kuehn's persistent research was to achieve a balanced reproduction of the tonal range of nature through photography and photomechanical printing. How differences in brightness in the original motif are translated into differences in brightness in a photographic layer can be determined from a characteristic curve that plots the relationship between exposure and the reaction of the light-sensitive material. According to Kuehn, the essence of the Syngraphy process is as follows: "The curve of the photographic paper is not linear but S-shaped. In order to achieve an image true to nature, the curve of the negative must be syngraphic, meaning S-shaped in reverse". To achieve flexibility in his charcacteristic curves, Kuehn eventually came up with a process that he patented in Germany in 1915 and again in 1929. It is based on the idea of combining two congruent negatives of the same motif—one exposed for a very short time, the other for an unusually long period of time; neither of the negatives on their own would produce a usable image. In 1933, in order to simplify

the process of making the photograph, he patented the idea for a special negative material which was coated with an emulsion on both sides of the plastic film support. This allowed the overexposure and the underexposure to be made on one negative, making it unnecessary to go through the painstaking process of exposing two separate negatives. Kuehn worked with Ernst von Oven, director of technology at Perutz, on this "syngraphic" film, which resulted in the correct gradation of tonal values. With Oven's death and the partial destruction of the Perutz plant in World War II, however, this research was discontinued.

TRI-COLOR GUM BICHROMATE PRINT

A bichromate process; gum bichromate print. This subtractive color process starts with three black-and-white negatives of a single motif. A multicolored image is created when the negatives are copied onto three pigmented bichromate gum arabic layers, each of which must have the respective complementary subtractive color. A blue filtered negative yields a yellow monochrome image, a green filtered negative results in magenta, and a red filtered negative creates the cyan image. In the gum bichromate process the full-color image is created by superimposing these three layers on a single piece of paper. After the first layer has been exposed, developed, and dried, another coating of light-sensitive, pigmented gum arabic is brushed on and then processed in the same way. The third layer is applied using the same procedure. Ideally the pigmented gum layers should be of the greatest possible transparency to guarantee optimal color mixing.

Around 1897 Kuehn only briefly experimented with this very complicated color process. He was dissatisfied with the lack of transparency of the pigments available to him. In addition, at that time black-and-white negatives were not equally sensitive to all colors of the spectrum. This made it very difficult to achieve similar gradations on the three separation negatives; this in turn resulted in color shifts in the final image.

Selected Literature:

Josef Maria Eder, *Das Pigmentverfahren, Öl-Bromöl- und Gummidruck, sowie verwandte photogr. Kopierverfahren mit Chromsalzen.* Ausführliches Handbuch der Photographie, vol. 4, part 2, Halle/Saale 1926

Ludwig David, *Photographisches Praktikum,* 7. edition, Halle/Saale 1931

Heinrich Kuehn, "Vom Nimbus der schwarzen Kunst," in *Das deutsche Lichtbild 1936* (Berlin, 1936), pp.1-14.

Louis Nadeau, *Encyclopaedie of Printing, Photographic and Photomechanical Processes,* 2 vol., New Brunswick 1994.

Robert Knodt und Klaus Pollmeier (eds.), *Verfahren der Fotografie,* exh.cat. Fotografische Sammlung im Museum Folkwang Essen, 2nd edition, Essen 1999.

Gordon Baldwin und Martin Jürgens, *Looking at Photographs: A Guide to Technical Terms*, Los Angeles: J. Paul Getty Museum, 2009

SELECTED BIBLIOGRAPHY ON HEINRICH KUEHN

A list of the approximately sixty articles that Heinrich Kuehn published will be found in *Heinrich Kühn Schriften zur Fotografie*, edited with commentaries by Astrid Mahler. This forthcoming publication also includes an extensive list of mentions of Kuehn in magazines, journals, catalogues and books published during his lifetime. In addition to Kuehn's own writings on technical topics and his studio diaries, the following bibliography provides a list of only the most important sources on the artist.

Heinrich Kühn, *Technik der Lichtbildnerei*. Halle an der Saale, 1921.

Heinrich Kühn, *Zur photographischen Technik*. Halle an der Saale, 1926.

Heinrich Kühn, "Erinnerungen an Hans Watzek." *Photographische Rundschau und Mitteilungen*, vol. 60, no. 6, 1923, pp. 85–90.

Heinrich Kühn, "Die photographische Bewältigung grosser Helligkeitsgegensätze." *Das deutsche Lichtbild. Jahresschau 1932*. Berlin, 1931, pp. T 23–T 31.

Heinrich Kühn, "Klarheit!" *Das deutsche Lichtbild. Jahresschau 1937*. Berlin, 1937, pp. T 11–T 18.

Writings about Heinrich Kuehn
No monograph was published about the photographer during his lifetime. The most representative publication was the portfolio *Gummidrucke von Hugo Henneberg – Wien, Heinrich Kühn – Innsbruck und Hans Watzek – Wien,* edited by Fritz Matthies-Masuren, Halle an der Saale, n.d. [1902]. Each of the authors contributed an essay to this volume. In the following a number of publications and articles are listed that provide further information about Heinrich Kuehn. These do not, however, include the numerous mentions in works about photography around 1900 or about photography in general.

A comprehensive bibliography of works on the Vienna Camera-Club can be found in Astrid Lechner, *Der Wiener Camera-Club und die Kunstfotografie um 1900. Diss.,* Vienna, 2005.

Alfred Buschbeck, "Das Trifolium des Wiener Camera-Clubs: Hans Watzeck, Hugo Henneberg, Heinrich Kühn." *Die Kunst in der Photographie*, vol. 2, no. 3, 1898, pp. 17–24.

M. (Fritz Matthies-Masuren), "Heinrich Kühn." *Photographisches Centralblatt*, vol. 5, no. 9, 1899, pp. 161–66.

Eugen Kalkschmidt, "Die Londoner Jahresausstellungen." *Photographisches Centralblatt*, vol. 8, no. 23, 1902, pp. 486–94.

Friedrich Carstanjen, "Über den Wert der Unschärfe in der Photographie." *Die Photographische Kunst im Jahre 1902*, pp. 69–81.

Friedrich Carstanjen, "Das Geheimnis der Stimmung in Bildern." *Die Photographische Kunst im Jahr 1903*, pp. 90–110.

E.R. Weiss, "Gummidrucke von Hugo Henneberg – Wien, Heinrich Kühn – Innsbruck und Hans Watzek – Wien." *Photographische Kunst im Jahr 1903*, pp. 69–80.

Georg Fuchs, "Die Photographie und die Kultur des Auges." *Photographische Kunst im Jahr 1905*, pp. 16–32.

Georg Fuchs, "Über das Wesen künstlerischer Betätigung." *Photgraphische Kunst im Jahr 1905*, pp. 96–112.

Friedrich Carstanjen, "Das Persönliche im Künstlerischen." *Photographische Rundschau und Photographisches Centralblatt*, vol. 19, no. 12, 1905, pp. 157–59.

Ernst Schur, "Über die künstlerischen Werte des Gummidrucks." *Photgraphische Rundschau und Photgraphisches Centralblatt*, vol. 20, no. 6, 1906, pp. 51–56.

Fritz Matthies-Masuren, "Hugo Henneberg, Heinrich Kühn, Hans Watzek." *Camera Work*, vol. 4, no. 13, 1906, pp. 21–41.

Fritz Matthies-Masuren, *Künstlerische Photographie. Entwicklung und Einfluss in Deutschland,* vols. 59 and 60 in the series *Die Kunst. Sammlung Illustrierter Mongraphien*. Edited by Richard Muther. Berlin, 1907, pp. 43.

Ernst Schur, "Photographie und Raumkunst." *Die Photographische Kunst im Jahre 1908*, pp. 86–112.
Camera Work, vol. 9, no. 33, 1911.

Josef Maria Eder, *Das Pigmentverfahren*, Öl- Bromöl- und Gummidruck, sowie verwandte photograph. Kopierverfahren mit Chromsalzen. Ausführliches Handbuch der Photographie, vol.4, part 2, Halle/Saale 1926.

Ludwig David, *Photographisches Praktikum*, 7. Edition, Halle/Saale 1931.

Robert A. Sobieszek, "Heinrich Kühn." *Image*, vol. 14, no. 5/6, 1971, pp. 10–18.

Heinrich Kühn 1866–1944. Photographien. Exh. cat. Galerie im Taxispalais, Innsbruck, 1976.

Allan Porter, special issue on Heinrich Kühn. *Camera*, vol. 56, no. 6, 1977.

Peter Weiermair (ed.), *Heinrich Kühn (1866–1844) Photographie*. Innsbruck, 1978.

Heinrich Kühn 1866–1944. 110 Bilder aus der Fotografischen Sammlung Museum Folkwang Essen. Essen, 1978.

Rudolf Kicken (ed.), *Heinrich Kühn (1866–1944)*. Cologne, 1981.

Peter Weiermair, "Von der Kunstfotografie zur Neuen Sachlichkeit." *Geschichte der Fotografie in Österreich*. Bad Ischl, 1983, pp. 187–202.

Enno Kaufhold, *Heinrich Kühn und die Kunstfotografie um 1900*. Berlin, 1988.

Ulrich Knapp, *Heinrich Kühn. Photographien*. Salzburg/Vienna, 1988.

Timm Starl, " '- sowie den Tiroler Bergen viele tausend Grüße…'. Über die Unfähigkeit, auch nur einen einzigen vernüftigen Satz zu Heinrich Kühn zu sagen, und die Fähigkeit, sogar daraus Kapital zu schlagen." *Fotogeschichte. Beiträge zur Geschichte und Ästhetik der Fotografie*, vol. 8, 1988, no. 28, pp. 107–08.

Timm Starl, "'Ein Vorkämpfer für die deutsche Kultur.' Der Werdegang Heinrich Kühns in biographischen Aufzeichnungen." *Fotogeschichte. Beiträge zur Geschichte und Ästhetik der Fotografie*, vol. 8, no. 28, 1988, pp. 49–54.

Louis Nadeau, *Encyclopaedie of Printing*, Photographic and Photomechanical Processes, 2 vol., New Brunswick 1994.

Phillip Prodger, "The Secret Passion of Heinrich Kuehn's Frau Ingenieur Richter." *Stanford University Museum of Art Journal*, vol. 24/25, 1994/95, pp. 25–32.

Wolfgang Ullrich, "Unschärfe, Antimodernismus und Avantgarde." Peter Geimer (ed.), *Ordnungen der Sichtbarkeit. Fotografie in Wissenschaft, Kunst und Technologie*. Frankfurt am Main, 2002, pp. 381–412.

Wolfgang Ullrich, *Die Geschichte der Unschärfe*. Berlin, 2002.

Christine Kühn, *Kunstfotografie um 1900. Die Sammlung Fritz Matthies-Masuren. 1837–1938*. Berlin, 2003.

Monika Faber and Astrid Mahler, eds., *Heinrich Kühn: The Perfect Photograph*. Exh. cat. Albertina, Vienna; Musée national de l'Orangerie, Paris; and Museum of Fine Arts, Houston, 2010–11.

PHOTOGRAPH AND COPYRIGHT CREDITS

We wish to thank the museums, galleries, and individuals named in the captions of plates and text illustrations for supplying the photographic materials in this publication. Photographer's contributions are gratefully acknowledged below.

Photograph Credits
Albertina, Vienna pp. 27, 67, 85 left, 92
Alexander Spuller Collection, Courtesy Galerie Johannes Faber pp. 79, 82
The Art Institute of Chicago p. 86 top (Photography © The Art Institute of Chicago)
Art Resource, New York pp. 8 (Image copyright © The Metropolitan Museum of Art. Image source: Art Resource, NY), 12-13 (Image copyright © The Metropolitan Museum of Art. Image source: Art Resource, NY), 21 (Image copyright © The Metropolitan Museum of Art. Image source: Art Resource, NY), 25 (Digital Image © The Museum of Modern Art/Licensed by SCALA / Art Resource, NY), 44-45 (Image copyright © The Metropolitan Museum of Art. Image source: Art Resource, NY), 47 (Image copyright © The Metropolitan Museum of Art. Image source: Art Resource, NY), 49 (Image copyright © The Metropolitan Museum of Art. Image source: Art Resource, NY), 50 (Image copyright © The Metropolitan Museum of Art. Image source: Art Resource, NY), 66 right (Digital Image © The Museum of Modern Art/Licensed by SCALA / Art Resource, NY), 86 middle (Image copyright © The Metropolitan Museum of Art. Image source: Art Resource, NY), 87 left (Image copyright © The Metropolitan Museum of Art. Image source: Art Resource, NY), 87 right (Image copyright © The Metropolitan Museum of Art. Image source: Art Resource, NY), 88 bottom (Image copyright © The Metropolitan Museum of Art. Image source: Art Resource, NY), 100 bottom (Image copyright © The Metropolitan Museum of Art. Image source: Art Resource, NY), 109 (Image copyright © The Metropolitan Museum of Art. Image source: Art Resource, NY); front cover (Image copyright © The Metropolitan Museum of Art. Image source: Art Resource, NY); back cover (Image copyright © The Metropolitan Museum of Art. Image source: Art Resource, NY)
Bayrische Staatsgemäldesammlung, Munich p. 46 left
Brian Buckley, New York pp. 20, 33, 34, 61, 78, 105
Bruce Silverstein Gallery, New York p. 48
Christian Brandstätter Collection, Vienna p. 99
Collection of Bob and Randi Fischer p. 53
Collection of Gary and Sarah Wolkowitz p. 104
Dietmar Siegert Collection, Germany p. 97
Galerie Kicken Berlin p. 29
George Eastman House, International Museum of Photography and Film pp. 17, 55, 59 top, 60, 70, 75, 90, 91, 114-115, 122
Höhere Graphische Bundes Lehr- und Versuchsanstalt, Vienna p. 106
Hulya Kolabas, New York pp. 68 right, 83

The Israel Museum, Jerusalem, pp. 2, 40 top
The J. Paul Getty Museum, Los Angeles p. 14 bottom
Lee Gallery pp. 76, 107
The National Gallery of Art, Washington, D.C. p. 86 bottom
Neue Galerie New York pp. 46 right
Österreichische Nationalbliothek, Vienna pp. 10, 41 top, 88 top, 89, 98, 121, 125
Photoinstitut Bonartes, Vienna pp. 35, 40 bottom, 52 top, 74, 85 right, 93, 94, 101, 103 left, 117
Raymond E. Kassar Collection, Courtesy Cheim & Read, New York pp. 20, 33, 34, 61, 78, 105
Wien Museum p. 64 left

Copyright Credits
For Alfred Stieglitz © 2012 Georgia O'Keeffe Museum/Artists Rights Society (ARS), New York
For Heinrich Kuehn © 2012 Estate of Heinrich Kuehn
For Oskar Kokoschka © 2012 Artists Rights Society (ARS), New York/ProLitteris, Zürich
For Edward Steichen © 2012 Carousel Research, New York

This book was published in conjunction with the exhibition

HEINRICH KUEHN AND HIS AMERICAN CIRCLE
Alfred Stieglitz and Edward Steichen

Neue Galerie New York, April 27–August 27, 2012

Director of publications: Scott Gutterman
Managing editor: Janis Staggs

Curator: Monika Faber
Installation: Tom Zoufaly

Book design: Judy Hudson
Translation: Steven Lindberg

Project coordination for Prestel: Anja Besserer
Production: Andrea Cobré
Origination: Pixelstorm, Vienna
Printing and binding: Passavia, Passau

For the text © 2012 Neue Galerie New York, 2012

© Prestel Verlag, Munich · London · New York 2012

Prestel Verlag, Munich
A member of Verlagsgruppe Random House GmbH

Neumarkter Strasse 28
81673 Munich
Tel. +49 (0)89 4136-0
Fax +49 (0)89 4136-2335
www.prestel.de

Prestel Publishing Ltd.
4 Bloomsbury Place
London WC1A 2QA
Tel. +44 (0)20 7323-5004
Fax +44 (0)20 7636-8004

Prestel Publishing
900 Broadway, Suite 603
New York, NY 10003
Tel. +1 (212) 995-2720
Fax +1 (212) 995-2733
www.prestel.com

Library of Congress Control Number: 2012932282

British Library Cataloguing-in-Publication Data:
a catalogue record for this book is available from the British Library; Deutsche Nationalbibliothek holds a record of this publication in the Deutsche Nationalbibliografie; detailed bibliographical data can be found under: http://dnb.d-nb.de

ISBN 978-3-7913-5196-4

Verlagsgruppe Random House FSC-DEU-0100
The FSC-certified paper Galaxi Supermatt was supplied by Papier-Union, Ehingen.

Illustrations

Front Endpaper: Max Horny, View of the first touring exhibition of artistic photography in the k.k. Österreichisches Museum für Kunst und Gewerbe, October 1899, from *Photographisches Centralblatt*, vol. 5, no. 19, 1899, p. 371. On the far end wall, photographs by Heinrich Kuehn, including *A Summer Day*.

Back Endpaper: Alfred Stieglitz, View of the exhibition *Austrian and German Work: Heinrich Kuehn, Hugo Henneberg, Hans Watzek, Theodor and Oscar Hofmeister* in the Gallery of the Photo-Secession in New York, 1906. The large image on the left wall is *Ploughman* by Henneberg, the small one is Kuehn's *Ploughman*. One the far right is *Sirócco* by Kuehn.

Page 1: Rudolf Katzung, *Ex Libris Heinrich Kuehn*, collotype after a pen drawing, ca. 1895. Private Collection

Page 2: Heinrich Kuehn, *Miss Mary*, ca. 1908, gum bichromate print, 30.5 x 22.9 cm (12 x 9 in.). The Noel and Harriette Levine Collection, at The Israel Museum, Jerusalem, repro photo by Anthony Troncale and Arturo Cubria, New York for The Israel Museum, Jerusalem

FSC
www.fsc.org
MIX
From responsible sources
FSC® C022274